EDINBURGH'S MILITARY HERITAGE

Gregor Stewart

AMBERLEY

First published 2019

Amberley Publishing
The Hill, Stroud
Gloucestershire, GL5 4EP

www.amberley-books.com

Copyright © Gregor Stewart, 2019

Logo source material courtesy of Gerry van Tonder

The right of Gregor Stewart to be identified as the
Author of this work has been asserted in accordance
with the Copyrights, Designs and Patents Act 1988.

ISBN 978 1 4456 8880 0 (print)
ISBN 978 1 4456 8881 7 (ebook)

British Library Cataloguing in Publication Data.
A catalogue record for this book is available from the
British Library.

Typesetting by Aura Technology and Software
Services, India. Printed in Great Britain.

Contents

Introduction 5

1. History 7

2. Local Conflicts 13

3. The Reformation 41

4. Oliver Cromwell 53

5. Edinburgh Castle 60

6. Buildings and Memorials 71

7. Edinburgh in More Recent Times 87

Bibliography 95

About the Author 96

Introduction

The military heritage of Edinburgh, Scotland's capital city, dates back to before records were kept. The city we see today, quite deceptive to the terrain, is, in fact, built over a series of seven hills, with bridges disguised as streets interconnecting the main areas. If we were to imagine it back in the early days, with its position at the point where the River Forth opens out into the North Sea, hills all around offering defensive positions and forests beyond, it is easy to see why this was considered an important part of Scotland to hold, resulting in it being much fought over.

Originally occupied by ancient Celtic tribes, the territory gave the Romans a harbour from which they could launch their campaign to try to take the rest of Scotland, before it fell under the control of the Angles of Northumbria, who battled with the Picts to retain control of what became their northern frontier. It was the Viking invasion around Berwick during the tenth century that cut off the supplies from the Northumbrians for modern-day Lothian and Edinburgh, allowing the Scots to retake control.

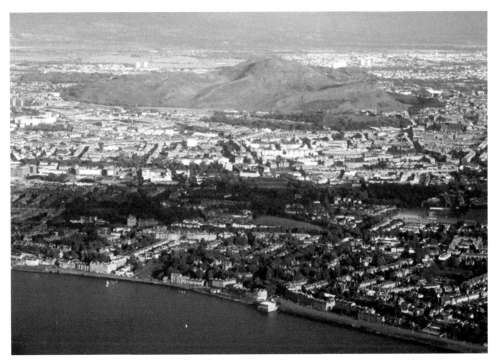

The city of Edinburgh showing Arthur's Seat rising in the centre. (Photo © Thomas Nugent cc-by-sa/2.0)

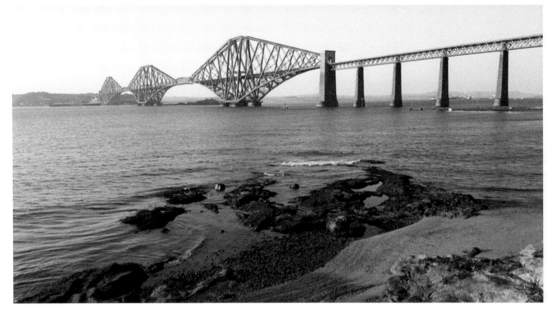

The Forth Rail Bridge has been in use since 1890, providing a vital transportation link to Fife and beyond, making it a target during the First and Second World Wars. (Photo © Clive Nicholson cc-by-sa/2.0)

The mighty stronghold on Castle Rock has existed since at least the twelfth century, although it is likely to have replaced earlier forts on the same spot. As the importance of Edinburgh grew, so too did the threat. The castle was seen as key to controlling Scotland, resulting in it becoming the most besieged in the whole of the United Kingdom, sieges that brought devastating destruction to the town of Edinburgh and those around it. Yet every time Edinburgh rebuilt and grew. Some of the most famous names in history played a part in both the building and ruin of Edinburgh, including King Edward I, also known as Edward Longshanks or the 'Hammer of the Scots'; King Robert the Bruce; Mary, Queen of Scots; Oliver Cromwell; and Bonnie Prince Charlie. Peace eventually arrived and was enjoyed for almost two centuries, until the German bombs struck during the First World War.

Throughout this book, I hope to take the reader through some of the key points in history, which had the greatest effect on both Edinburgh and the surrounding towns; to explain the reasons behind these conflicts and implications not just for the local area, but often for the country as a whole. I will also explore some of the lesser-known monuments dedicated to Edinburgh's military past and how the remnants of the city's long history and traditions remain main tourist attractions to this day.

1. History

With the castle perched high on top of a volcanic plug, there can be few towns or cities across the United Kingdom with a more visual reminder of its military importance, both past and present, than Edinburgh. Castle Rock, as this once virtually inaccessible peak became known, has been the site of a stronghold for so long that the details of the earliest fortifications have been lost to history and are now nothing more than disputed conjecture. Throughout this chapter I will look at the key stages throughout Edinburgh's history, before exploring the local battles in more depth in the next chapter.

The lands around modern-day Edinburgh were once occupied by the Ottadeni tribe and the Gadeni tribe, with the Ottadenis holding the land from the Tyne to the Forth, and the Gadenis region being the neighbouring inland area. Although there are no records, it is highly likely that the Ottadeni tribe would have utilised the natural defences offered

The view looking up Castle Rock, showing how impregnable the site was to early forces. (Photo © kim traynor cc-by-sa/2.0)

The town of Cramond, chosen by the Romans to establish a fort and harbour. (Photo © Ronnie Leask cc-by-sa/2.0)

by Castle Rock to construct some form of fort. When Romans arrived, most likely around AD 80, a series of forts were constructed in the area and again, while it is not documented that they occupied the site of the current castle, had any defensive structure existed here it would have certainly been taken and used, rather than be left in the hands of their foes. Some academics argue that this was the site of the Castrum Alatum, meaning the 'Winged Camp' of Ptolemy, the Egyptian geographer. This is equally disputed by others, as although there are some similarities in the description given, Ptolemy is said to have described the camp as being close to the top of Scotland, which Edinburgh clearly is not. It is possible that he was, however, referring to Roman-occupied Scotland.

The existence of a Roman camp at Cramond, on the outskirts of modern-day Edinburgh, is not disputed, and this port was established around the natural port to allow supplies to be brought in by boat. These supplies and materials were used not only to support the Roman legions, but to construct a series of forts from which the Romans would launch attacks on the rest of Scotland, and to later build the Antonine Wall, the second major Roman frontier designed to hold back to the Picts from Roman territory.

After the withdrawal of the Roman forces, the area was once again held by the Picts, and it is much contended whether a fortification was once again constructed on the hill. Those who believe such a building existed state it stood from around the middle of the fifth century, and state it was named Castel Mynedh Agnedh, or the 'Maidens' Castle', and that it was used not only to provide defence for the surrounding territory, but also to hold the daughters of the royalty and senior nobles until they were old enough to be married. The region became under the control of Northumbria once again and with successive battles for the control of the area, any castle would have required continuous repair

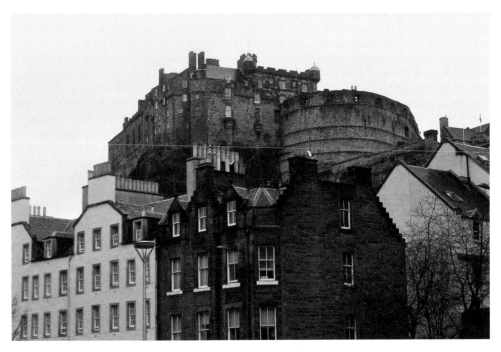

Edinburgh Castle perched high above the surrounding buildings.

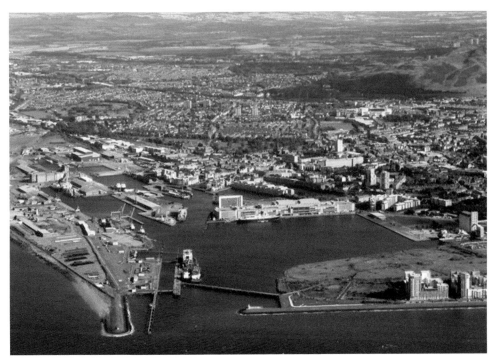

Leith today, now an expansive suburb of Edinburgh that developed through the importance of the port. (Photo © M J Richardson cc-by-sa/2.0)

and rebuilding. By the twelfth century, Edinburgh was firmly under the control of the Scots, and the edifice officially known as Edinburgh Castle was first constructed on the orders of King David I as a defensive royal household.

Throughout this time, Leith was developing as a port. The early history of Leith is largely unwritten and can only be taken from records from other towns and regions. It is highly likely the Romans occupied Leith to some point, as their known route through Scotland passed straight through the region. The Romans, however, seem to have overlooked Leith as a port, choosing Cramond instead. The Vikings are also known to have used the Firth of Forth during their invasion as a natural harbour, with all the villages along the coast likely to have suffered some threat or attack. The history of Leith is fortunately documented from around the twelfth century, and although it remained completely separate from Edinburgh, the town suffered considerably through the following centuries as the battle to control the region continued.

The Scottish Wars of Independence signalled the start of a long period when the control of the castle passed between the Scottish and the English, along with some of the most famous battles in history at nearby Stirling, a much-fought over crossing point for the River Forth. The castle was extensively damaged several times over this period, including by King Robert the Bruce, who ordered that the castle be destroyed to avoid it falling into English hands again. The end of the Wars of Independence did not signal the end of the battles for sovereignty over Scotland, and with Edinburgh being declared the capital of Scotland in 1437, both the town and the castle remained a main target for invading forces.

The site of the Battle of Stirling Bridge.

A view of the battlefield at Bannockburn. (Photo © Stanley Howe cc-by-sa/2.0)

In 1544 the English invaded under the orders of King Henry VIII, triggering the start of a period known as The Rough Wooing. King Henry was angered that an earlier agreement for Mary, Queen of Scots to be betrothed to his son was not being honoured, and instead opted to try to 'persuade' the Scottish authorities, by force, that the agreed future marriage should go ahead. Leith was to suffer extensively during this period, with it being particularly targeted by the king's commanders.

It was not just, however, invading forces that brought battles to the streets of Edinburgh. The Protestant Reformation would bring not only mob unrest to the area, but a conflict that would mark the beginning of the end of Scotland's long military alliance with France, and early indications that a new alliance with the English was a viable option. The return to Scotland of the adult Mary, Queen of Scots would provoke further disputes as the fight for both Crown and Church continued, leading to the Lang Siege of Edinburgh Castle, and its importance as a military stronghold rather than a defensive royal residence being realised.

Any hopes that the Union of the Crowns of England and Scotland in 1603 might bring peace between 'Auld Enemies' were soon dashed when both the political and religious differences were once again highlighted, resulting in the Bishops' Wars, which not only brought England and Scotland to conflict again, but caused internal civil unrest between the Scots, and ultimately saw the rise of Oliver Cromwell, Lord Commander of the Commonwealth. With the Scottish authorities refusing to accept the rule of Cromwell,

his New Model Army of highly skilled soldiers marched north. Yet unlike previous invaders, Cromwell did not leave a trail of devastation behind him, but instead brought heavy investment to not only reinstate damage caused through quelling any opposition he faced, but to improve facilities for the townsfolk.

The Jacobite uprising brought an initial unsuccessful fight for the castle, and while the 1707 Act of the Union brought opportunities for the merchants of the city through access to trade with the British Empire, it also brought mass unrest and rioting to the streets of Edinburgh with the majority of ordinary people being against the union. The houses of the authorities, who were paid handsomely for their support of the union, were attacked by what became known as the Edinburgh Mob, and nobles were at such high risk of attack on the streets that few dared leave the safety of their homes without bodyguards to protect them.

Further Jacobite uprisings brought fresh risks to Edinburgh and the castle, with Bonnie Prince Charlie occupying Holyroodhouse for several months while a siege by letter played out. This brought to an end the military conflict in Edinburgh, yet the city remained of vital military importance, with the castle being used as a prison for the foreign wars, and defences being built at the port of Leith during the Napoleonic War. The nineteenth century saw the importance of Edinburgh recognised, and the Scottish National War Memorial being established within the castle. Traditions brought about through Edinburgh's history still draw large crowds, such as the one o'clock gun, initially established as a daily maritime time signal for the captains of the ships in the Forth, that has been fired from Edinburgh Castle since 1861, and the Royal Military Tattoo, which has brought military displays from across the world to Edinburgh annually since 1950.

2. Local Conflicts

Although Edinburgh is known across the world for is military heritage, it grew from the small settlements on the banks of the River Forth that were first established by the early Celtic tribes, as the river provided both the means for supplies and offered protection.

The Picts are known to have occupied the area north of Edinburgh, on the opposite banks of the River, yet it is likely they also used the lands around Edinburgh. Evidence of this was found in the nineteenth century, when it was discovered that a large stone slab, measuring approximately 1.1m by 0.7m, that was being used as a footbridge in the city's Princes Street Gardens, did in fact have Pictish symbols carved into it. Upon realising the importance of the stone slab, it was removed and gifted to the National Museum of Antiquities of Scotland in 1861.

Little is known of the Picts due to two main reasons, the first being that there are virtually no written records from the Pictish people themselves, and the second being that what early records do exist were largely written by the invading Romans and are unlikely to give a fair and accurate account of these ancient people. The name 'Picts' itself was first recorded by the Romans in 297 and means 'Painted People', representative of their warpaint and a good indication that the Romans saw the Picts as fierce opponents. Although the Picts did not leave written records, they did leave a large number of carvings, such as those on the stone slab mentioned above. Good examples of these also survive in the caves around the villages of Wemyss in Fife, on the opposite banks of the River Forth.

The first significant military action in the area is likely to have taken place during the Roman invasion. The Romans arrived on the island now known as Great Britain in AD 43 in Kent. Having marched north, seizing control of large parts of the country, their legions first set foot in modern-day Scotland in the middle of the first century. Despite their savagery, the Romans brought considerable infrastructure, including a road network, to the country. A Roman road, known as Dere Street, dates back to AD 77, and connected York to Edinburgh and beyond, and allowed for the transportation of both soldiers and supplies as they sought to take control of Scotland.

In AD 77, Gnaeus Julius Agricola was appointed the Roman governor of Britain. Agricola led his legions into Scotland and, as he approached the site of Edinburgh, he was faced with two options. He needed to reach the land between the River Forth and River Clyde to move his forces north, and he could take a relatively direct route, which would take him across hills and bring the associated danger, or he could march as far as the Firth of Forth, and then march along the banks. Historical accounts tell us that Agricola was a skilled military commander and he could see the strategic advantage of the position of Inveresk, and so he proceeded in that direction, towards the Forth Estuary.

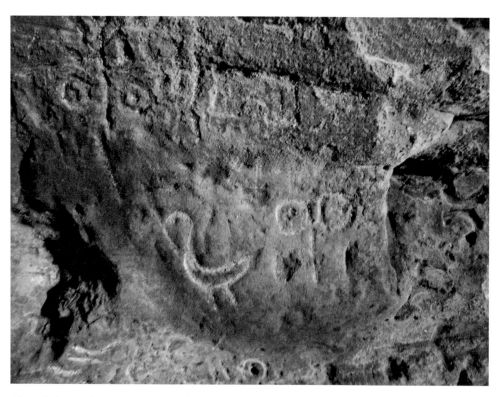

Above, below and opposite: The Pictish carvings that can be found in the Wemyss Caves, Fife.

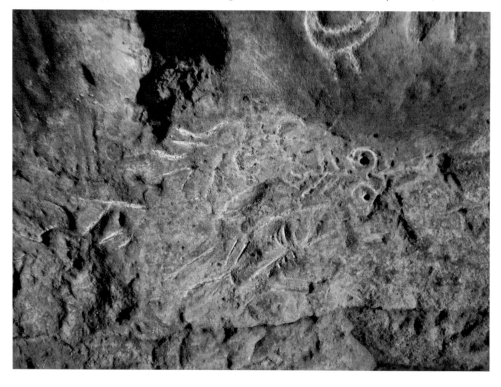

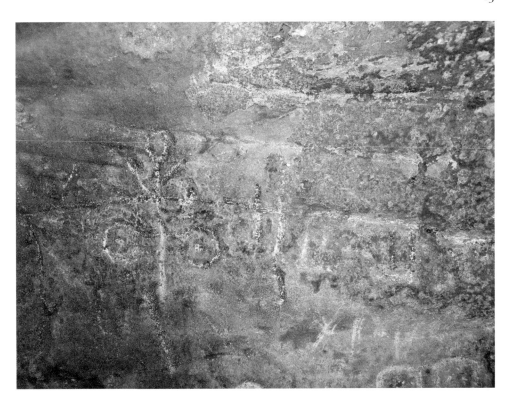

He is believed to have had a fort built here, with a larger fort, covering around 6.6 acres and of sufficient size to house the cavalry, built around 100 years later. While there is little information relating to battles in the area, in 2007 a tombstone was discovered in a field at nearby Carberry. The stone depicted a cavalryman named 'Crescens' and shows he was a guard to the Roman emperor, both a sign of the importance of the fort, and an indication that there was localised conflict, in which at least one of the guards lost his life. General Agricola is said to have left a garrison at the fort at Inveresk to secure the area while he led his remaining legions onwards. A wooden bridge would have been constructed to cross the River Esk, which has since been replaced several times with this former military crossing point still in use today.

Although the exact crossing point for the River Forth used by General Agricola is uncertain, it is believed he took the route over the Forth taking the islands, to successfully march north to take control of much of Scotland, before returning to the safety of their frontier at the Firth of Forth and being recalled to Rome in AD 85. As the Romans withdrew, the Picts returned.

Probably the biggest impact the Romans had in the area was the fort and harbour they built at Cramond, on the outer edge of Edinburgh. The Romans had made further

Dere Street crossing the Dun Law approaching Edinburgh. (Photo © Richard Webb cc-by-sa2.0)

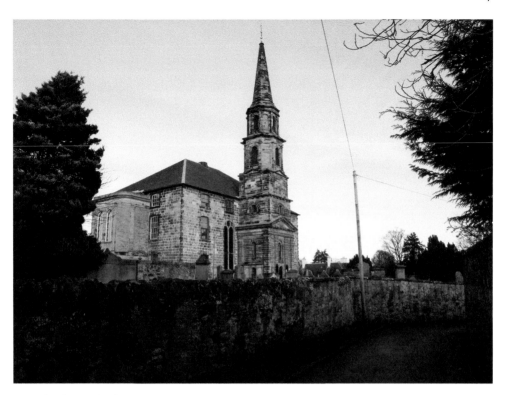

St Michael's parish church, Inveresk, is over 200 years old and occupies the site of a second-century Roman fort. (Photo © Euan Nelson cc-by-sa/2.0)

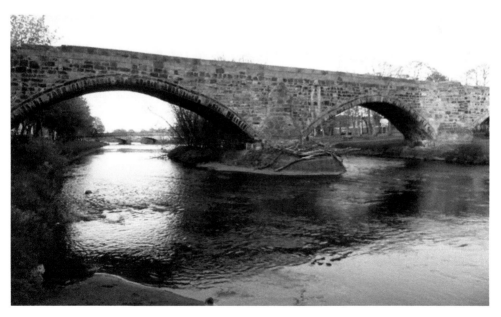

The Auld Bridge in Inveresk, known locally as the Roman Bridge. (Photo © Kim Traynor cc-by-sa/2.0)

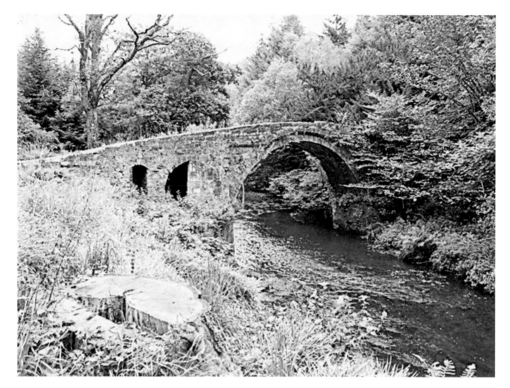

Old Roman Bridge over the North Esk. (Photo © M J Richardson cc-by-sa/2.0)

Fishwives' Causeway in Portobello incorporates part of an old Roman road. (Photo © M J Richardson cc-by-sa/2.0)

failed attempts to take control of Scotland, with the most famous symbol of this probably being Hadrian's Wall, constructed on the orders of Publius Aelius Hadrianus from around AD 122 to protect the Roman-held territory from attacks from the Picts. His successor, Emperor Antoninus Pius, held a desire to make a final attempt at seize the country, and although he never travelled to Great Britain himself, he appointed Quintus Lollius Urbicus as Governor of Britain and ordered that further attacks were to be made north of Hadrian's Wall. Some small gains were made, and a fort was built at Cramond between AD 140 and AD 142, by which time the order was issued to cease, and a wall known as the Antonine Wall was built between the Firth of Forth and the Forth of Clyde to secure the territory that had been taken.

The initial fort is likely to have been modest, rectangular in shape and believed to incorporate an existing village, yet the strategic importance as a military base would play an important part in shaping not just the local area, but the country. It is believed Cramond was picked by the Romans due it being the point where the River Almond opens into the Firth of Forth. Although now narrowed through silting, the opening here would

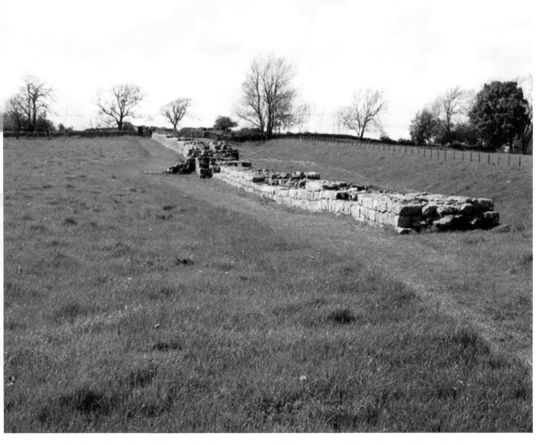

A stretch of Hadrian's Wall near Black Carts Farm. (Photo © David Purchase cc-by-sa/2.0)

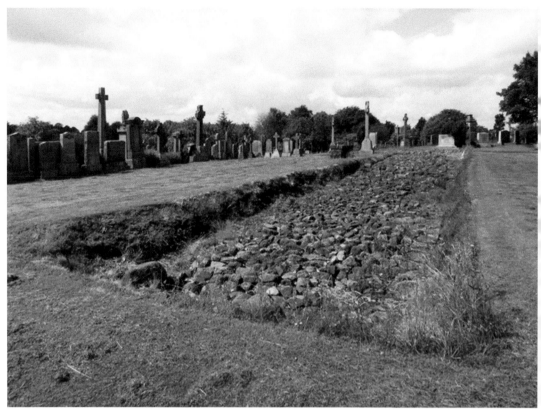

A section of the base of the Antonine Wall at New Kilpatrick Cemetery. (Photo © Lairich Rig cc-by-sa/2.0)

have been much wider and deeper during Roman times, offering a natural harbour and supply route inland for relatively large boats. It is from here that it is believed materials, men and supplies were landed for the construction of the Antonine Wall, hence the fort being constructed to provide protection for this vital port. Although some distance from the wall, the fort at Cramond also provided additional defences for the Roman frontier that the wall represented, protecting the Forth from any attempts to launch attacks from Fife. An unusual feature of Cramond is an island in the Forth known as Cramond Island, which is accessible via a causeway at low tide. Although there is no evidence of Roman habitation in the Island, it is almost inconceivable that this would not have been utilised, offering defences into the river itself. By AD 170, the Antonine Wall was deemed too difficult to defend, and the Romans again retreated once again to the safety offered by Hadrian's Wall.

The final significant attempt to take Scotland was led by Emperor Septimius Severus in AD 208. He utilised the earlier Roman military bases, including the fort at Cramond, which, along with a port at South Shields to the south, and one a Carpow on the Tay to the north, provided a naval supply chain for his campaign. The fort at Cramond will have almost certainly been used by the natives following the earlier Roman withdrawal; yet

whether it was retaken by force or simply abandoned once word of the advancing Roman legions reached those living there is unclear. The fort was, however, extensively rebuilt and enlarged to around 5 acres in size. Harbour facilities were also constructed along the shores of both the River Forth and the River Almond. Cramond is believed to have been the principal base to provide supplies to the Roman forces in Scotland, with boats arriving from the southern parts of Britain and from Continental Europe. The Cramond fort was being prepared to offer a significant settlement.

Despite all the preparation for the advancement north, the invasion led by Severus was short-lived, and he died in York in AD 211. His son, Caracalla, succeeded him as emperor, yet did not share his father's ambitions to take Scotland, and the Roman forces once again withdrew to behind Hadrian's Wall, with the fort at Cramond never reaching its full potential. It was, however, soon occupied by the local population and it was the site chosen to construct the first Christian church around AD 600.

After the withdrawal of the Romans, the area around Edinburgh became fiercely fought over. It was during this time that the much-contested claim is made that the Picts

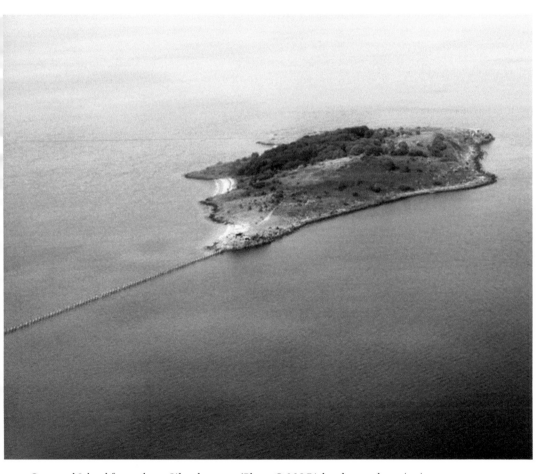

Cramond Island from above Silverknowes. (Photo © M J Richardson cc-by-sa/2.0)

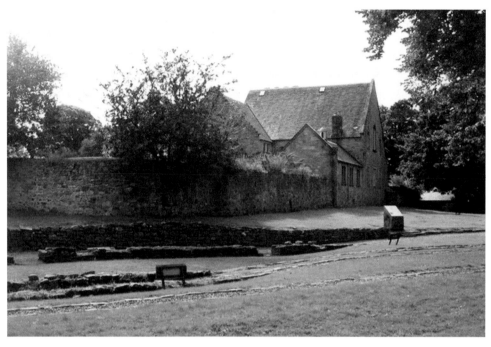

Excavations marking part of the Cramond Fort site. (Photo © David Purchase cc-by-sa/2.0)

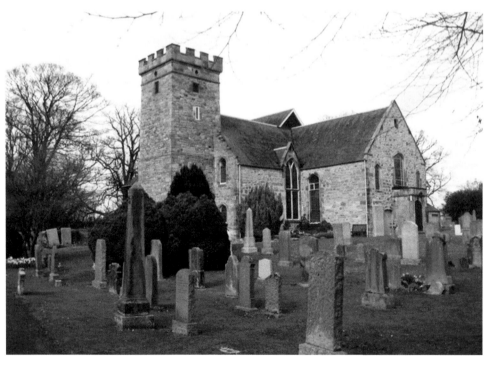

In the second century AD a Roman fort stood on this site but there has been a place of worship here since the sixth century. (Photo © James Denham cc-by-sa/2.0)

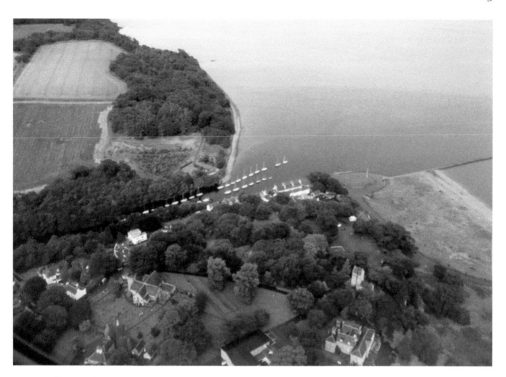

Cramond viewed from above showing where the River Almond joins the Firth of Forth, the chosen site for the Roman harbour. (Photo © Thomas Nugent cc-by-sa/2.0)

The Eagle Rock derives its name from a carving of an eagle, believed to have been from the time of the Roman occupation. Sadly, there are no traces of the carving now. (Photo © Stephen Samson cc-by-sa/2.0)

established a fortress on Castle Rock, the site of the current castle. It is believed that if such a castle existed, it first faced significant military action in AD 452, when King Vortigern of the Britons joined forces with the Saxons to attack and seize the fort.

The idea of an ancient castle in Edinburgh originates from the early writing of the Myrvyian, or Cambrian Archaeology. In this work, a stronghold named Caer-Eiddyn, meaning the Fort of Edin, is mentioned, and it is said this was the home of a Celtic chief named Mynydoc. In AD 510, Mynydoc faced the Saxon forces of Ida, the flame-bearer, at Catraeth in Lothian. It is written than 300 warriors, dressed in fine armour, rushed from the fortification at Caer-Eiddyn to join the battle. It was, however, a Saxon victory, with control of the castle passing to the invaders. Although there is a battle of Catraeth recorded, it is believed this took place around AD 600 in North Yorkshire, which casts doubt on the story of early Edinburgh; however, it is said by some that it is from the Fort of Edin that Edinburgh derived its name.

Over the following centuries, several other early writings tell of the battle for the castle in Edinburgh. In AD 685, it is said that King Egfrid of Northumberland was defeated and the castle once again became a stronghold of the Picts and Scots, yet as no accurate historical records exist, and with the names of towns and areas being open to misinterpretation, these writing cannot unfortunately be relied upon. The first documented evidence of the castle comes from an account written by John of Fordun, a fourteenth-century historian, who tells that Queen Margaret was living at the Castle of the Maidens, in Edinburgh, when she received the news of the death of her husband, King Malcolm III, in November 1093.

The Wars of Independence

The establishment of a royal household at Edinburgh caused the town and castle to be a main focus in the ongoing tensions between the Scottish and English monarchies. It was generally considered that holding Edinburgh Castle would grant command over Scotland as a nation. The death of King Alexander III in 1286, close to Kinghorn in Fife, created an opportunity for King Edward I of England, resulting in a period known as the first Wars of Independence.

King Alexander left no heirs, resulting in much contention over the Scottish throne. The closest direct living relative was his granddaughter, Margaret of Norway, yet when this was contested by the Scottish nobles, the rulers of Norway sought the help of the English king to resolve matters. King Edward's ruling was that eight-year-old Margaret was to be brought from Norway as the heir to the Scottish throne, and she would marry King Edward's son, also Edward, once they were of age, effectively unifying the crowns. However, Margaret fell ill while making the journey to Scotland, and died on 26 September 1290.

Scotland was again thrown into turmoil, and King Edward's hopes to unify the crowns peacefully had been dashed. However, he was to have another opportunity. There were two main contenders for the crown: Robert Bruce (grandfather to the more famous Robert the Bruce) and John Balliol. With the risk of civil war, the Scottish nobles once again asked King Edward to intervene and rule on who should be crowned. Edward requested

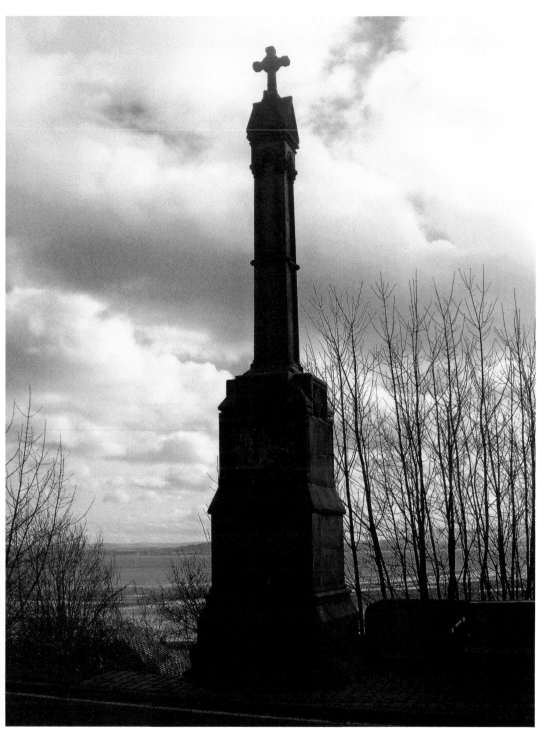

The Alexander III monument in Fife marks the approximate location the king was unsaddled from his horse during a storm and fell down a cliff to his death.

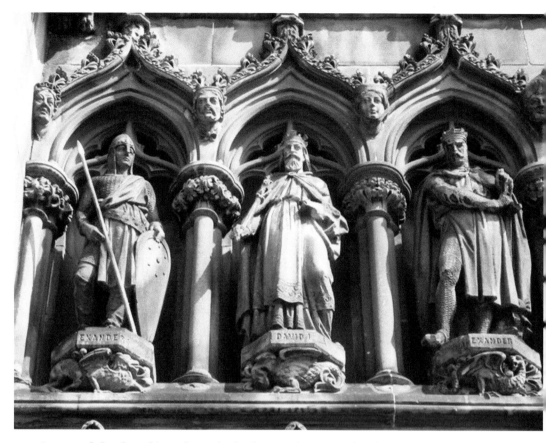

Statues of the three kings from the lead-up to the Wars of Independence. (Photo © kim traynor cc-by-sa/2.0)

that both men accept him as their overlord, before making a decision, a request that both declined on the basis that only the king could surrender the power of the country, and so until one of them had been crowned, they could not answer.

King Edward was not to be beaten however, and turned to the legal system of the time, which said that he was able to adjudicate between two claimants, yet if there were more than two claimants, he could decide who would be King. With a total of thirteen potential claimants, and the risk that all were to be brought into the contest, both Bruce and Balliol paid homage to him and agreed to see him as their overlord should they be made king.

Eventually, John Balliol was crowned, yet almost immediately King Edward began to interfere with the ruling of Scotland, including demanding that the Scots provide troops to join the war between England and France. Scotland had a long-standing allegiance with France, and so joining the English in a battle against them was a step too far. Instead, in 1296, King Balliol signed an allegiance with France, which was seen as a declaration of war against England. Enraged, King Edward marched north with a massive army and Edinburgh in his sights.

After the defeat of the Scots at the Battle of Dunbar, around 30 miles from Edinburgh, King Edward marched on the capital. King Balliol had, by this time, fled to Forfar and with weak rulership, many great castles of Scotland were simply surrendered to him. The mighty Edinburgh Castle held out for one week against King Edward's attacks before being captured. Edward continued to pursue King Balliol and, after completely humiliating him and forcing him to withdraw his alliance with the French, he returned to England, taking with him many of Scotland's historical records, artefacts and treasures, resulting in them being lost to the nation and a main reason why it is so difficult to research early Scottish history. He left commanders and around 325 soldiers at Edinburgh to retain control.

The castle remained under English control for eighteen years until 14 March 1314, when Sir Thomas Randolph, nephew of Robert the Bruce, launched an attack. He split his forces into two, with one group launching a fake attempt to take the castle through the main gates. With the English garrison distracted, the rest of his men scaled the north face of Castle Rock and launched a surprise attack from within the castle, successfully taking the castle back. The castle was destroyed by the Scots on the command of Robert the Bruce, to prevent it from falling into the hands of the English again. After Bruce's victory at the Battle of Bannockburn, Edinburgh Castle remained abandoned and in ruins for over two decades, when it was once again a target for the English during the Second War of Independence.

The English forces once again advanced into Scotland under the rule of King Edward III in 1335, both by land and sea. While the army marched to Perth via Carlisle on the west coast, his ships sailed up the east coast, carrying massive amounts of military supplies and provisions, towards the Firth of Forth, where they attacked and destroyed the abbey at Inchcolm Island. While the king waited at Perth, Guy II, Marquis of Namur, who was the cousin of the English queen and an ally of King Edward, landed at Berwick on 30 July, where he disembarked with around 300 cavalrymen. It seems he had little knowledge of the king's battle plans, as he marched towards Edinburgh, under the assumption that Edward would have left no enemies behind him.

Upon reaching Edinburgh, he was met by the combined armies of the Earl of Moray and Earl of March at an area known at the Borough Muir. A full-scale battle ensued, which the Scots may have lost had it not been for the arrival of William Douglas with reinforcements. Overwhelmed, the marquis retreated with his men from the battlefield to within the walls of Edinburgh, where they made their way up to the castle, pursued by the Scottish forces. With the castle still in ruins, they were able to access it relatively easily, yet were faced with the difficulty of how to defend their position. The order was given for all of the men to dismount, and to slaughter the horses, before the corpses were used to block gaps in the castle walls and provide a rather horrific defence. They held out until the next day, and when faced with no other option, they surrendered on the condition that their lives would be spared. Their surrender was accepted, on the basis that they would agree to never bear arms against King David II of Scotland again, and the Earl of Moray escorted them to the Borders and out of Scotland.

After receiving news of the Battle of Borough Muir, King Edward moved towards Edinburgh and successfully took both Castle Rock and the castle. With their supply ships in the Forth, the castle was refortified, with additional defences and towers added, and remained in the hands of the English for further six years until April 1341, when Sir William Douglas seized one of the English supply ships. One of his men, disguised as an English merchant, was able to meet with the governor of the castle, and offered his cargo of wine, beer and biscuits. To ensure a deal was done, he had taken with him samples of the beer and wine, which were given to the governor and a price was agreed. Delivery of the goods was to take place early the following morning, under the pretence that the merchant wished to avoid the risk of an attack from the Scots, when the reality was that was exactly what was being planned.

The following morning, he approached the castle gates, along with of his men disguised as the sailors from the ship to conceal both their identities and weapons. They brought with them a large cart with the supplies. They were granted access to the castle, and as soon as they were inside, they overturned the cart to use as a defence, and attacked and killed the sentries.

A warning horn was sounded to call the English to arms within the castle, yet this too was a pre-agreed sign for a large band of heavily armed Scots who had hidden around the castle gates to attack. The entire garrison of around 100 English soldiers were slaughtered, and with the castle back in Scottish hands, the English were forced out of Scotland.

Perhaps the most devastating attack of the Wars of Independence took place in 1356. Known as the Burnt Candlemas, King Edward III again invaded Scotland, accompanied by Edward Balliol who sought to restore his family's claim to the Scottish crown. The invasion was to be by land and sea, with a massive army on land and a fleet of ships sailing towards the River Forth to attack from the sea and to provide supplies to the land forces. The townsfolk, who were in the path of his army, fled, taking with them their cattle and as much as they could carry, and burning anything that they were unable to carry that could be of use to the English army. King Edward decided to fight fire with fire, literally, and burned every building and all the fields of crops that he passed to the ground. He spent ten days in the town of Haddington, approximately 20 miles east of Edinburgh, destroying almost the entire town. As he reached Edinburgh, the burnings continued with historians of the time reporting that almost all of Lothian had been put to flames.

Yet King Edward's ruthlessness was to be his downfall. His fleet of ships had anchored at Berwick on their way to meet his army, but had been sunk in a massive storm there. With the buildings, and more importantly food supplies, behind Edward's forces destroyed, he had to reconsider his attack on Edinburgh. He had lost his fleet of ships, along with the supplies and many men. He had also lost a large number of soldiers in his land attacks, yet he had gained nothing. The territory he had gained had no value and without the aid of his supply ships, an attack on Edinburgh Castle would be difficult. Instead he decided to return to England and in 1357 the Treaty of Berwick was signed, which signalled the end of the Second War of Independence.

Site of the 1296 Battle of Dunbar. (Photo © Richard Webb cc-by-sa/2.0)

St Mary's Church, Haddington. A twelfth-century Franciscan abbey stood on the site before being destroyed during the Burnt Candlemas. (Photo © James Denham cc-by-sa/2.0)

St Mary's Church, Whitekirk. Many believe that the damage caused to the Shrine of Our Lady at the church brought about the wrath of God and the great storm that destroyed the English fleet. (Photo © M J Richardson cc-by-sa/2.0)

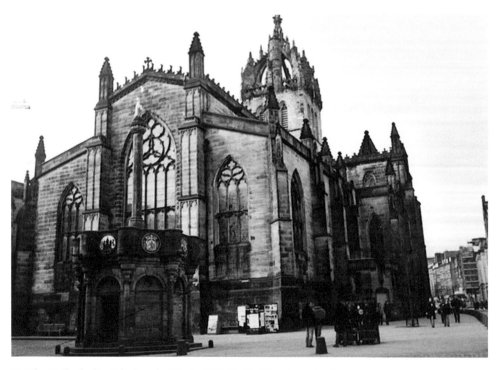

St Giles Cathedral in Edinburgh. (Photo © Colin Smith cc-by-sa/2.0)

The destruction caused was devastating for the entire region. No building had been off limits, with many churches destroyed. Even St Giles Cathedral in Edinburgh suffered damage, with much of the present building believed to be from the restoration after. The whole region had to be rebuilt, not just to provide shelter, but crops renewed to provide food. During the rebuilding work, stonemasons were employed by the burgh to vault sections of St Giles to provide additional strength, and David's Tower was constructed at the castle to celebrate the release of King David II from his imprisonment in England. This was the first tower house in the city, and at over 100 feet tall, it would dominate the Edinburgh skyline for 200 years. It is often said that in these times, the most devastating weapon that could be used was fire, and the Burnt Candlemas is a prime example of this.

The Rough Wooing

In the mid-sixteenth century, Scotland again entered into a period of conflict with England. The death of King James V in 1542 left his infant daughter, Mary, as the heir to the throne. This was at a time of religious unrest, with the Protestant reformation sweeping across Europe, and England having already converted to the Protestant religion under King Henry VIII. The opportunity for the English monarch was therefore twofold. If he could secure an agreement for his son Edward, he could not only unite the crowns but also unify the country under the Protestant religion. With Scotland still a devoutly Catholic country, this was a threat to both the Scottish monarchy and Church.

An agreement was, however, met, with the Treaty of Greenwich in 1543, which agreed to peace between the two countries, and the marriage of Mary to Edward once they were of age. Under pressure, the Scottish parliament threw out the agreement, instead favouring the marriage of Queen Mary to Francis II of France, Scotland's old ally and a Catholic country. In revenge, King Henry launched a series of attacks on Scotland to try to 'persuade' Scotland to honour the terms of the Treaty of Greenwich by force, in what became known as the Rough Wooing. Although most of the country suffered at the hands of the English forces, Leith was without a doubt one of the worst affected towns.

On 4 May 1544, Lord Hertford, the king's lieutenant of his royal army, sailed into the Firth of Forth. It is said that the people of Edinburgh and Leith could only stand and watch as his fleet of 200 ships arrived and set anchor in the waters before them. Word had reached the townsfolk of the approaching forces a few days earlier; however, it was too late for any sizeable army to be gathered and so the orders to fortify the towns in any way they could had been issued. The following day the English army landed, unopposed. Their goal was to seize Leith, a vital port for them to harbour their ships and to bring their full forces, artillery and supplies to shore. As they marched towards their target, they were met by the forces of The Regent Arran and Cardinal Beaton, yet they offered little real threat to the massive English army, which is estimated to have consisted of around 10,000 men.

Their entry to Leith was similarly unchallenged, with many of the townsfolk already having fled. Over the following week they ransacked the town and burned many of the buildings to the ground. During that time, the defences around the town were also improved, and the larger ships brought into the harbour, allowing the large artillery guns to be offloaded and prepared to be pulled to Edinburgh.

Edinburgh comprised of the old walled city, with many houses outside the walls due to the lack of space. Leaving around 1,500 men to protect Leith, the English army marching on the city comprised of five divisions of troops and twelve heavy artillery guns. As they approached the gates to the walled city, known as the Netherbow, they came under fire from citizens in the surrounding houses. It caught them by surprise, and some were killed, but with their location revealed, the citizens fled and the English proceeded. A message was received that the Provost of Edinburgh, Sir Adam Otterburn of Redhall, sought to meet with Lord Hertford, which was granted. Accompanied by several of the town's burgesses, Otterburn offered to hand over the keys to Edinburgh, on the basis that the citizens were allowed to leave with one bag each, and none of the town was to be put to the flames. Hertford's response left it clear what his intentions were. He told Otterburn that unless the town yielded, and its citizens – man, woman and child – be put out to the fields to his will and pleasure, he would take the town by force, and put all to the sword and fire.

It was an impossible decision for Otterburn. The English force was massive, and the only protection they had was from within the castle, which they could not access. He decided it was better to stand and fight than yield to their enemy. It was a brave decision, and with several shots from one of their heavy artillery guns, the gates to the city were breached. Up to 400 Scots were killed in the battle that followed, yet with cannon fire raining down on them, the castle proved too well protected for the English forces to succeed in the goal of taking Edinburgh, and they retreated. As they did so, the town was set alight, with it being said it burned for several days, with Lord Hertford's troops watching from the surrounding vantage points, taking some delight in the cries of citizens who had lost everything.

The Isle of May in the Firth of Forth, where the English fleet first anchored. (Photo © Malcolm Neal cc-by-sa/2.0)

St Ninian's Chapel, Leith. St Ninian's was one of the buildings destroyed when the English first arrived at Leith. (Photo © John Lord cc-by-sa/2.0)

Following the burning of Edinburgh and Leith, cavalry were sent out to around a 5-mile radius of Edinburgh, with instructions to seize as much as they could, including cattle, and to burn what they could not. From Leith, the ships were instructed to leave harbour, along with two Scottish ships belonging to King James himself, and were described to be not just laden with booty, but to be cumbered, meaning dangerously overloaded, with booty. Before leaving, every remaining building in Leith was set alight, and the pier was smashed, with the wood from it burned to ensure it could not be hastily rebuilt. Lord Hertford returned to England by land, accompanied by his army, and continued their devastation, setting fire to the buildings of every town they passed through. Once again both Edinburgh and the surrounding towns required rebuilding, while war continued around the country.

In a bizarre twist of fate, most of the English fleet were called upon to join the battle against the French, and the plague struck Newcastle, leaving the Leith mariners free to transport goods to most of the trade routes, raising much-needed funds that helped to rebuild both the town and harbour. It was not long, however, before the English forces were back.

The site of the Netherbow Port, where the English forces fired on the gates of the old walled city. (Photo © kim traynor cc-by-sa/2.0)

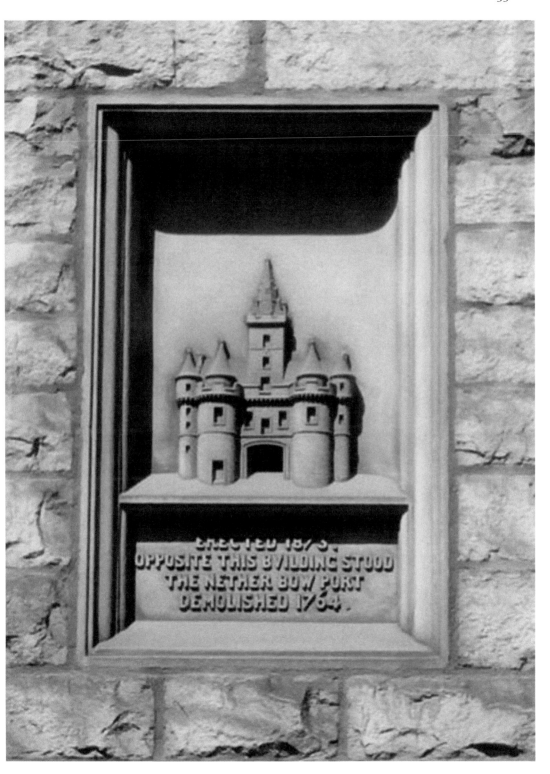

A plaque marking the site of the Netherbow Port. (Photo © kim traynor cc-by-sa/2.0)

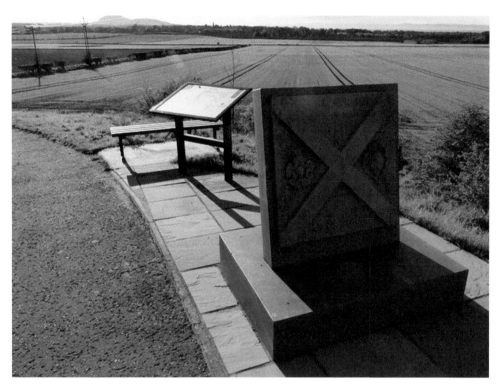

A memorial stone to the Battle of Pinkie Cleugh. (Photo © Mat Fascione cc-by-sa/2.0)

Fa'side Castle. This fifteenth-century tower house was set alight and extensively damaged by the English just before the battle. (Photo © M J Richardson cc-by-sa/2.0)

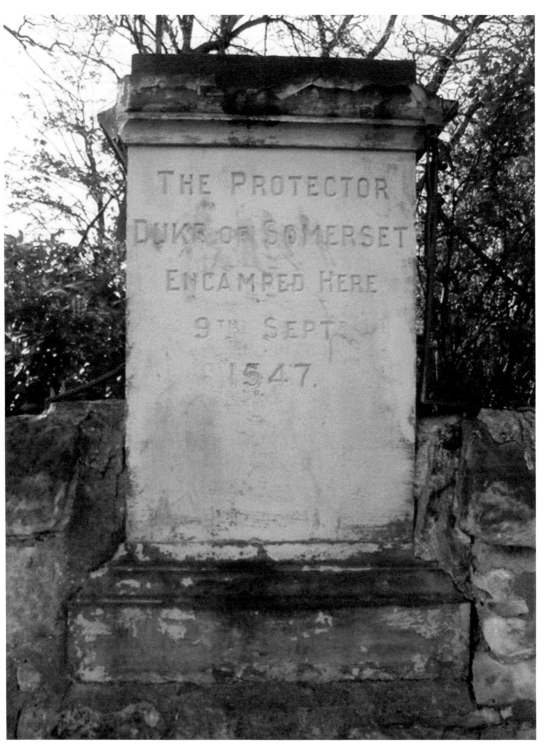

This marker stone shows the approximate location of the English army camp. (Photo © kim traynor cc-by-sa/2.0)

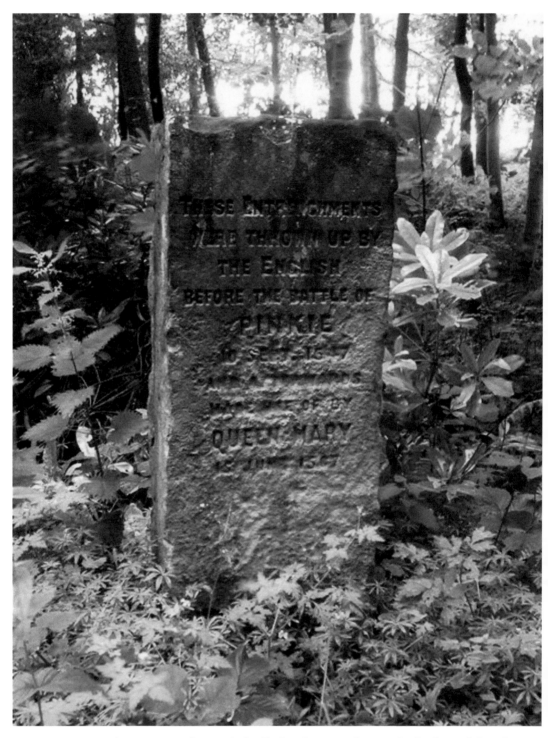

A Victorian marker stone at Carberry, which tells that the entrenchments dug by the English at the Battle of Pinkie Cleugh were used twenty years later by the forces of Queen Mary in her final battle. (Photo © kim traynor cc-by-sa/2.0)

Somerset's Mound. Although disputed, this earthworks is believed to have been formed by the English forces during the Battle of Pinkie Cleugh to mount the Duke of Somerset's cannon. (Photo © kim traynor cc-by-sa/2.0)

The Battle of Pinkie Cleugh was fought just outside the town of Musselburgh, near Edinburgh, on 10 September 1547. It was a decisive victory for the English, to the extent that the day became referred to as Black Saturday in Scotland.

The day after the battle, the English followed the coast and marched on Leith, no doubt expecting to find rich pickings once again. The residents had, however, been well warned and taken, along with their possessions, to the safety of within the walls of Edinburgh Castle. The harbour too had been emptied of all vessels, except thirteen old vessels, many of which were in such poor condition they were not seaworthy.

With little to do other than contemplate their next move, the English army set up camp at Leith and again set about causing widespread destruction. After a week, they again returned to England, but not before setting the ships and town alight once again. The English vessels in the Forth also left, leaving a garrison at both the islands of Inchkeith and Inchcolm to retain control of them.

The following year, in June 1548, the French arrived at Leith to aid in besieging Haddington, one of the last English strongholds. In return for their assistance, a parliament was held at the nunnery near Haddington, and a treaty was agreed with the French for Queen Mary to be wed to Francis of France, and the five-year-old queen was transported to France, where she would live for the next thirteen years. The French had brought with them not just military assistance, but engineers and representatives from wealthy noble families, and so the rebuilding of key defences, including Edinburgh Castle and Leith, commenced. Hostilities with England continued until 1550, when the Treaty of Boulogne was signed, ending the war between France and England, and bringing peace to Scotland.

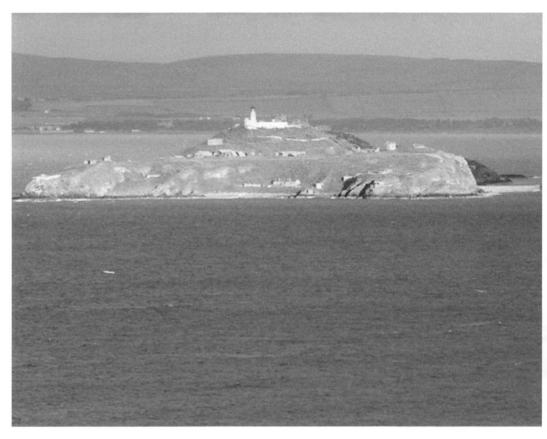

Inchkeith Island in the Firth of Forth. (Photo © Simon Johnston cc-by-sa/2.0)

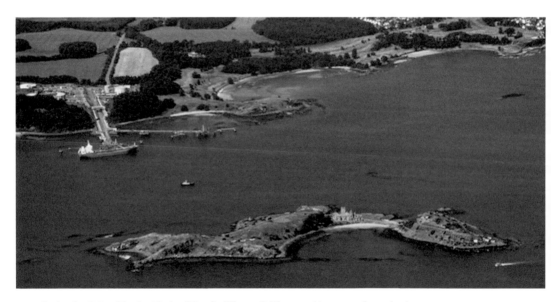

Inchcolm Island in the Firth of Forth. (Photo © Thomas Nugent cc-by-sa/2.0)

3. The Reformation

Not all military conflicts affecting Edinburgh came from invading forces; some were from within the country, with few having a bigger impact that the Protestant Reformation.

As mentioned earlier, the Protestant Reformation swept through Europe, and while some countries switched relatively easily, Scotland had a strong Catholic influence from the Cathedral at St Andrews in Fife. This was where the Catholic Church had grown through the centuries, and the archbishops yielded great power, leading to St Andres being referred to as Scotland's Rome. In order to put the events of this period of history into context, it is important to briefly recall the religious position at that time.

Although there had been some religious unrest in Scotland for some time, it was the burning of Patrick Hamilton that signalled the start of unstoppable change in the country. Hamilton had travelled across Europe, where he heard the preaching of reformers such as Martin Luther. When he returned to Scotland, he took up studies at St Andrews University, where he eagerly told his fellow students of the Protestant movement in Europe. In hindsight, to do so right under the nose of the powerhouse for the Catholic Church in Scotland was not the best idea, and the student soon came to the attention of Dr James Beaton, Archbishop of St Andrews. Beaton acted swiftly. He had Hamilton arrested, and after a short show trial, he was sentenced to death for heresy. On 29 May 1528, Patrick Hamilton was burned at the stake in a botched execution that resulted in him taking six hours to perish. Such was the public unrest at such barbarity, Beaton was warned by his advisors that no more reformers should be executed in public. The advice was ignored however, and Henry Forrest was later burned on the high ground above St Andrews harbour, ensuring the flames were seen far and wide as a warning.

Persecution of the Reformers was also taking place in Edinburgh, with sailors arriving at Leith from Europe and telling local lairds and clergy of the new ways, only for those who accepted it to find themselves being burnt at the stake on Castle Hill. It was, however, the actions of Cardinal David Beaton, who became archbishop in 1539, that would signal the end of the rule of the Catholic Church. Beaton was an unpopular man, and following the death of King James, he produced falsified documents to try to take control of the country as the regent for Queen Mary. His attempts failed and, humiliated, he focused his frustration to the Reformers. One preacher in particular, George Wishart, caught his attention. Wishart had built up a considerable following and, despite failed attempts to discredit him and to have him assassinated, his preaching continued to attract large crowds. In 1546, Beaton had Wishart arrested and sentenced to death. His burning point was outside St Andrews Castle, which Beaton watched from the luxury of his private chamber within. This did not go unnoticed by Wishart's supporters, and just weeks later, ten of his allies successfully sneaked into the castle and secured themselves inside. Cardinal Beaton was killed in his chambers, and the castle was held for a year until the French navy arrived and bombarded

it from sea and land. The Reformers within surrendered to the French, and were taken as galley slaves. Among them was John Knox, a former bodyguard for George Wishart, and later to become known as the Father of the Reformation.

By the time of the release of John Knox to England, the Reformation was already taking a strong grip in Scotland, with many religious establishments being attacked and destroyed. Knox continued preaching from England, before making a dramatic return to Scotland in 1559 when he marched an army through Edinburgh to St Giles Cathedral, where he entered unopposed and delivered a passionate sermon. Such was the impact of this that just a few days later Knox was elected the minister of St Giles, and the Catholic decoration of the building was removed.

In Scotland, the Reformation also brought a somewhat unique problem. The French, a Catholic nation, had for years aided Scotland in their battles against the English, a Protestant country. Ill feeling was growing not just against the Catholic Church, but against the French military based in Scotland. To add to the difficulties, Mary, Queen of Scots was Catholic, still residing in France, with Scotland being ruled by her mother and regent, Mary of Guise, a devout Catholic, leading to a difficult and often confrontational relationship between the Queen Regent and Edinburgh's burgh administration.

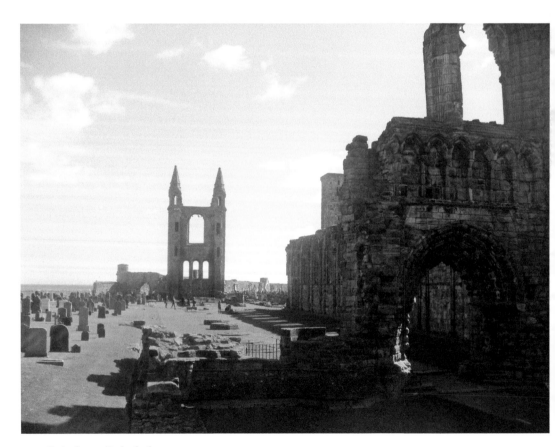

St Andrews Cathedral.

St Salvator's Chapel, St Andrews.

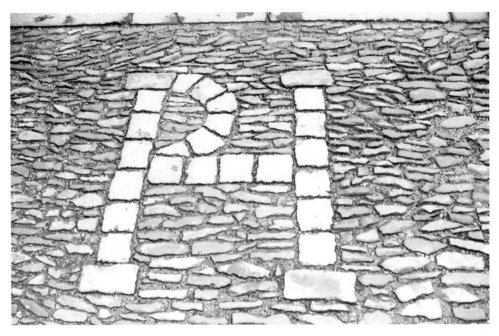

The initials 'P H' set into the cobbled ground marks the approximate location of Patrick Hamilton's execution.

St Andrews Castle, where Cardinal Beaton watched the execution of George Wishart.

The initial 'G W' set into the road to mark the approximate location of George Wishart's execution.

As concerns grew about the French influence in Scotland, the Reformers aligned themselves behind John Knox, who had been released from his time in the French galleys and had returned to England where he continued preaching, before arriving back in Scotland in 1559. Combined with other religious leaders sympathetic to the Protestant cause, the managed to raise and army of around 12,000 troops and set about trying to remove the French from the country, declaring themselves to the 'Lords of the Congregation'. With the risk of violent conflict becoming very real, a treaty named the 'Articles of Leith' was drawn up in 1559 between the Lords of the Congregation and Mary of Guise, which agreed a truce and for the settlement of the Church to be reviewed in Parliament the following year. When French reinforcements arrived in Leith, this was seen as a warning to the Lords of the Congregation that the treaty may not be adhered to, and in response they looked to Queen Elizabeth of England for assistance. The Duke of Norfolk was sent to Berwick as her representative, and an agreement named the Treaty of Berwick was made to agree terms for the English fleet to come to Scotland to aid the Lords of the Congregation's forces in removing the French from the country and for Scotland to convert to the Protestant faith. Needless to say, both the French forces and the Scottish authorities, who were still loyal to the Queen Regent, prepared to do battle.

The French had troops around Edinburgh, and those based at Haddington moved to Leith, which was by then a fully fortified town. The first battle took place at Restalrig, now

a residential suburb of Edinburgh, with casualties on both sides. Localised battles around Edinburgh and on Leith Links became more bloody, and attempts were made to take Leith, which was seen as key in the success of the Reformers, but the reinforcements proved too strong. There was however a problem for the estimated 3,000 French troops within the walls of Leith. With battles raging around, and the English fleet occupying the mouth of the Forth, no supplies could be brought to the town and famine was setting in. Meanwhile the bombardment from the heavy cannons continued to cause mass destruction.

The town would have almost certainly been completely destroyed, and all within killed, if it were not for the death of Mary of Guise at Edinburgh Castle. This presented an opportunity to negotiate the end of the Siege of Leith, with agreement being made that the surviving French troops would be transported from Leith back to France by the English navy. The implications of this were significant across the country. It not only ended the twelve-year occupation of French forces in Leith, but also signalled the end of the Auld Alliance between Scotland and France, and closer ties between England and Scotland. In 1560, the Scottish parliament abolished papal authority in the country and, despite having a Catholic queen, it was decreed that Scotland was a Protestant country.

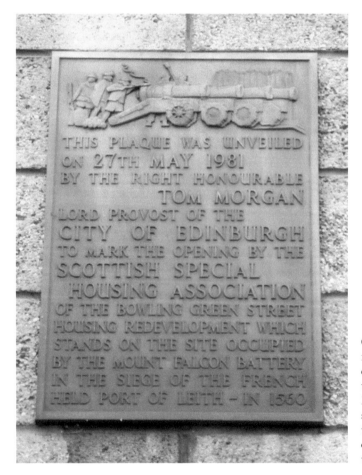

Commemorative plaque marking a housing estate constructed on the site occupied by the Mount Falcon Battery set up by the Protestant troops during the Siege of Leith. (Photo © kim traynor cc-by-sa/2.0)

The former Crabbie's Warehouse at Great Junction Street that follows the line of the French fort in Leith. (Photo © kim traynor cc-by-sa/2.0)

Pilrig House in Leith incorporates parts of an earlier building occupied by the English forces during the siege. (Photo © kim traynor cc-by-sa/2.0)

These earthworks at Leith Links are believed to have been used to mount two artillery guns. (Photo © kim traynor cc-by-sa/2.0)

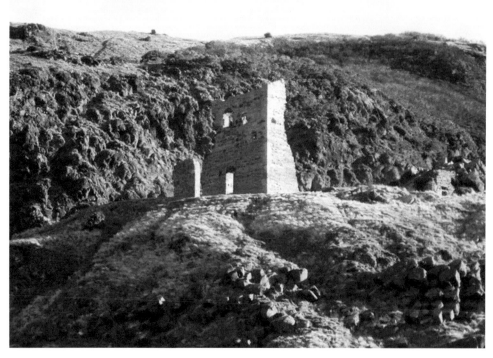

St Anthony's Chapel in Holyrood Park is one of many chapels that fell into disrepair following the Reformation. (Photo © kim traynor cc-by-sa/2.0)

A section of stone wall on Drummond Street that once formed part of the Dominican Priory of the Blackfriars, which was destroyed during the Reformation. (Photo © kim traynor cc-by-sa/2.0)

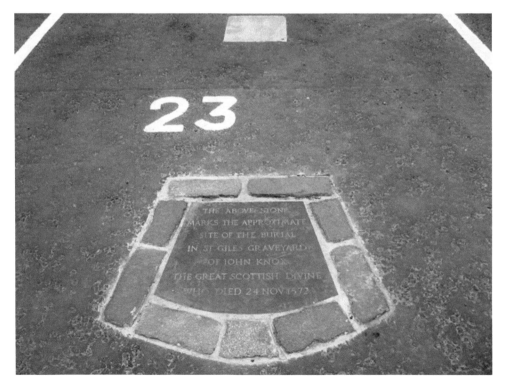

The memorial plaque and marker in Parliament Square indicating the location of the grave of John Knox. (Photo © kim traynor cc-by-sa/2.0)

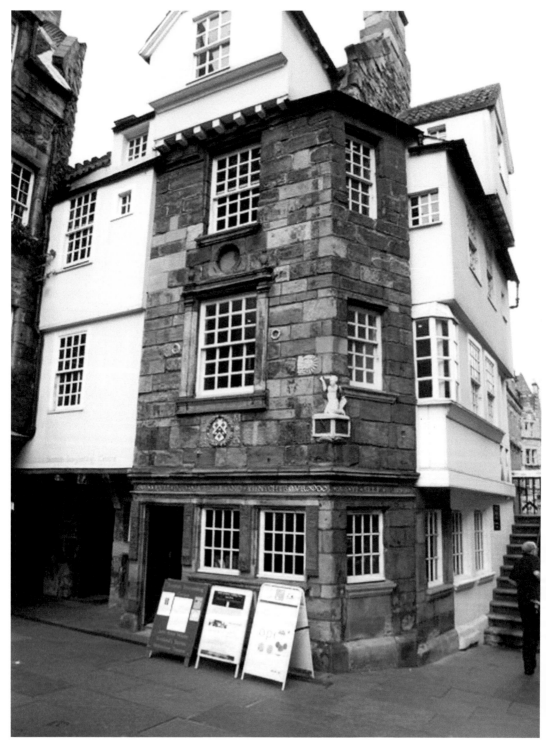

This property in Edinburgh is known as John Knox House, although it is debated whether he did actually live there. (Photo © Dave Hitchborne cc-by-sa/2.0)

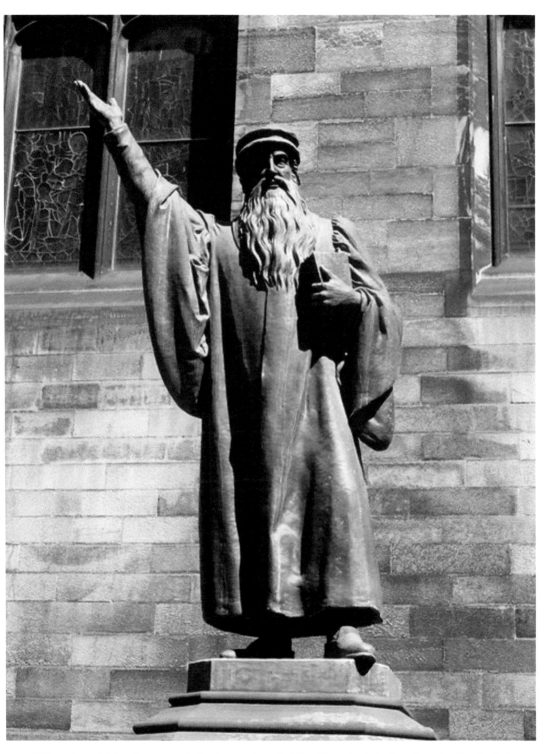

This statue of John Knox stands in the courtyard of the Church of Scotland's main theological college. (Photo © kim traynor cc-by-sa/2.0)

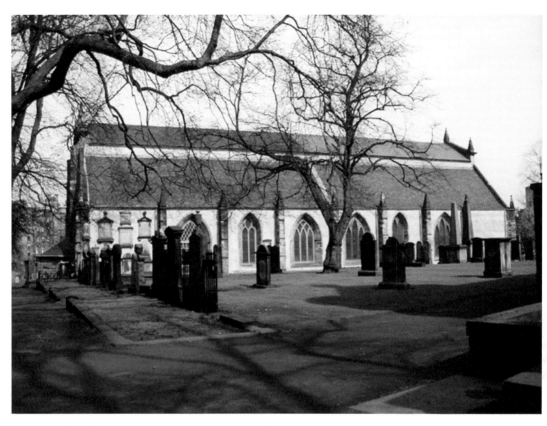

Greyfriars Kirk was the first church built in Edinburgh after the Reformation, and takes its name from the friary that once stood on the site. (Edinburgh Photo © Kevin Rae cc-by-sa/2.0)

4. Oliver Cromwell

One of the most famous and vilified figures in British history is Oliver Cromwell. Yet while most have heard of him, not so many know his role and, as with previous major incidents, it is important to give a short background on this to put into context his impact on and around Edinburgh.

The death of Queen Elizabeth I of England, with no direct heirs, in 1603 resulted in the English crown being handed to her cousin as closest living relative. That cousin was King James VI of Scotland, resulting in the crowns of the two kingdoms that had been at war for centuries finally being unified.

Yet it was not an easy unification, as both countries still sought to operate very separately from each other and, despite the Reformation, still had different religious beliefs. The English parliament also made things difficult for the Scottish king, and when he passed away in 1625, he had achieved relatively little. His son, Charles I, succeeded him to the throne, and with ambitions to make the changes his father had hoped to, he quickly realised that one of the main stumbling blocks was religion. It was not long, however, before he discovered just how difficult an issue this was. With the Covenanter movement growing, battles followed that proved to be unsuccessful in gaining any changes. The English parliament were losing patience with their king wasting money and resources on what they viewed as battles that were not their concern, and a plot had been put in place to form a new fighting force, named the New Model Army. King Charles was arrested, and civil war broke out in England, until eventually, heavily influenced by one of the military commanders of the New Model Army, Oliver Cromwell, King Charles was tried for treason and executed in 1649.

Cromwell defeated any remnants of the Royalist forces and the English parliament declared England to be a republic, with Cromwell as the Lord Protector. Scotland, however, took a different route, and declared Charles II as their king. This was seen as an act of defiance, and after failed negotiations, Cromwell invaded in 1650. His first target was Dunbar, the only sizeable port at the time between Berwick and Leith, which was protected by Edinburgh. By taking Dunbar, he would then have a naval supply route to move towards Edinburgh and beyond.

His plans were foiled however by the forces of Sir David Leslie, who held out in the trenches around the fortifications of Leith and Edinburgh, thwarting every attempt Cromwell made to advance on the towns for a month. The harbour mouth at Leith had been blocked with a ship's boom to prevent any vessels from entering, and even attacking the town from the sea with fireballs proved fruitless. Cromwell grew both confused and frustrated at not being able to break through the Scottish lines, and returned to Dunbar to consider his next steps.

Perhaps spurred on by his success, Leslie followed with the hopes to push Cromwell back further and out of Scotland once and for all. This was, however, to be his downfall.

While their defensive tactics had worked, his young and inexperienced troops were no match for the soldiers Cromwell had selected for their experience in open battle. In September 1650, the two forces met at the Battle of Dunbar, which was a decisive victory for Cromwell. Leslie retreated to Stirling, where King Charles had been staying, leaving Edinburgh and Leith unprotected.

After the defeat at Dunbar, almost all those within Leith had fled, allowing Cromwell to march his army to the safety provided by the town walls. He opted to lodge himself in Edinburgh, with a large part of his army being stationed at Holyrood. His next target was Edinburgh Castle.

Many of the townsfolk, along with the ministers from the churches, had fled to the castle prior to the arrival of Cromwell, with the soldiers inside headed by Governor Dundas. Cromwell wasted no time in tackling the unenviable task of trying to take the castle, and had heavy guns placed strategically to commence an almost continuous bombardment. Despite his reputation, Cromwell however sought to win Scotland not by force, but by convincing the people to join the Commonwealth, and so a series of letters began to change hands between Governor Dundas and Oliver Cromwell.

Upon receiving communication advising that the ministers and the people who sought shelter in the castle were starving, Cromwell offered them free liberty to return to their churches to preach. Yet with a ban on political speeches, the ministers declined the offer. With his first attempt to win over the ministers failing, Cromwell and his men delivered sermons in the churches of Edinburgh to the people, while the siege of the castle continued against those who opposed him.

Despite one successful break from the castle, in which Captain Augustin led a charge against Cromwell's forces, the siege continued into September, leading to Cromwell

The view from Doon Hill overlooking the site of the Battle of Dunbar. (Photo © Mick Garratt cc-by-sa/2.0)

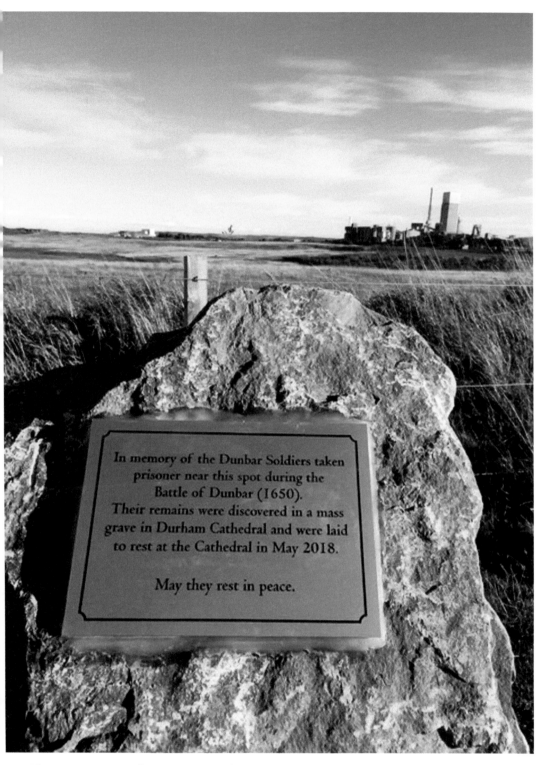

The commemorative plaque in memory of the Dunbar soldiers. (Photo © Jennifer Petrie cc-by-sa/2.0)

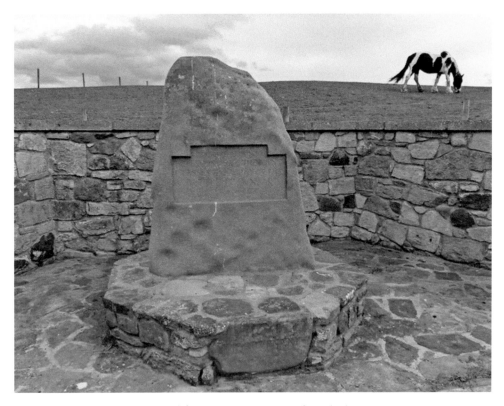

The Battle of Dunbar monument. (Photo © Mat Fascione cc-by-sa/2.0)

The Cromwell Harbour at Dunbar. (Photo © James Denham cc-by-sa/2.0)

trying a different approach. He called upon the colliers of East Lothian and had them start to dig excavations into the rock below the castle on the south side. The intention was not to dig a tunnel into the castle, but just to dig deep enough below to be able to place explosives and cause a castle collapse. Word was sent to the English parliament that they had got more than 60 yards into the rock, and this no doubt also reached those within the castle. Larger, more powerful guns arrived in December, and Cromwell had a further letter delivered to Governor Dundas summoning him to meet and surrender the castle. Dundas replied saying he would need to consult with those whom he held the castle for, leading to Cromwell offering to send any citizen of Edinburgh to the castle for the period of one hour to explain what was going on outside the castle, but unfortunately those chosen by Dundas refused to do so.

With Dundas showing indecision, on 18 December Cromwell issued a further letter, simply stating that if commissioners were sent from the castle, with full authorisation to negotiate on behalf of the governor, safe terms would be agreed to the surrender of the castle. The discussions took place, and on 24 December the castle, its guns and ammunition were handed to Cromwell's forces.

Unlike previous English invaders, Cromwell's generals did not seek to destroy the towns they took and instead invested in the rebuilding of both the structures and defences. In Leith, plans were put in place to once again fully fortify the town, but with the Edinburgh

The remains of Cromwell's Citadel in Leith. (Photo © kim traynor cc-by-sa/2.0)

This is all that remains of Cromwell's mighty Citadel at Leith. (Photo © kim traynor cc-by-sa/2.0)

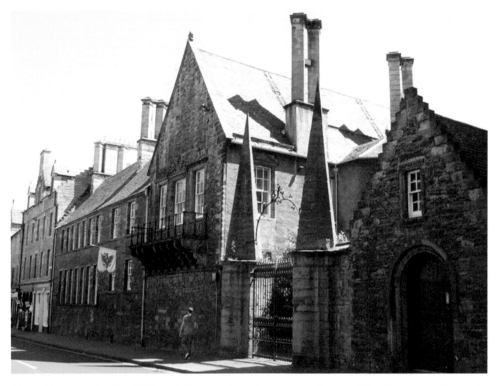

Moray House on the Royal Mile is believed to have been where Cromwell lived when in Edinburgh. (Photo © kim traynor cc-by-sa/2.0)

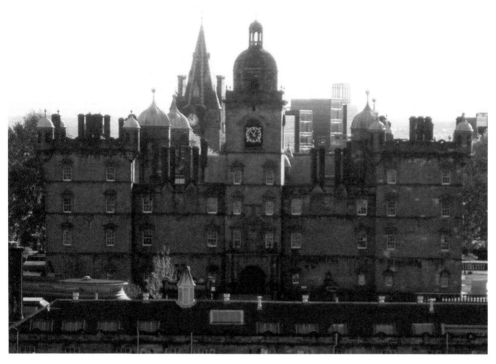

Work on George Heriot's Hospital was not fully completed when the building was taken by Cromwell and converted into an infirmary for his forces. (Photo © kim traynor cc-by-sa/2.0)

authorities fearing this would once again give the opportunity to enclose the port of Leith, they instead offered to contribute towards the costs of the construction of a large citadel within the town, in which Cromwell's garrisons and weapons were housed.

After Cromwell's death in 1658, the politics of the country once again took a turn, with King Charles being returned to the British throne in 1660. One of the first orders issued by Charles was for the destruction of all of Cromwell's citadels and associated structures, and it is for this reason that although his name is known, his actions are not.

5. Edinburgh Castle

With Edinburgh Castle being central to many conflicts within Scotland, and with a total of twenty-three sieges – it being the most besieged castle in the country – it would be impractical to not devote a section of the book to this mighty fortress. Many of the attacks have already been covered; however, in this chapter three of the main sieges not yet mentioned will be explored.

The Lang Siege started in 1571, during the Third English Civil War. Secretary Grange held the castle in behalf of Queen Mary, when in May an opposing force led by the Earl of Lennox, a supporter of the infant King James VI, attacked. The initial siege was on the entire town of Edinburgh, which lasted for a period of one month, followed by a further siege in October of the same year. With the castle being the ultimate prize, the Earl of Lennox sought military assistance from Queen Elizabeth I of England, while Secretary Grange put the stonemasons to work to bolster the castle's fortifications and sent a message to France that they were under attack. Rather than military aid, Queen Elizabeth sent a representative to negotiate a treaty. A short truce was agreed, which saw control of Edinburgh town going to the earl, and the castle remaining in the hands of Grange, in the hope that matters could be resolved.

On 1 January 1573, the townsfolk of Edinburgh were awoken by artillery fire from the castle. The truce had expired with no resolution in place, and with the Earl of Morton now in charge of the king's force, it seemed Grange was not willing to wait to see what his first move would be. It was perhaps a foolhardy move however, as with relatively small supplies of gunpowder and cannonballs, and no chance of any supplies getting through the town, it had used up valuable defences against any attack. Meanwhile the Earl of Morton had his men poison the well that provided water to the castle, and to place themselves in fortified positions around the castle.

A month later, with water supplies running low, Grange continued his bombardment of the town, yet was only succeeding in destroying the buildings and killing civilians, resulting in any support he had from the townsfolk quickly dwindling. In April military assistance for the king's men arrived, with Sir William Drury leading 1,000 men and twenty-seven heavy guns into the town. The cannons were set up to attack the castle from all angles, and between 17 and 23 May, it was estimated that 3,000 shots were fired. The result was devastating for the castle, with David's Tower and Constable's Tower being destroyed. Debris blocked the door for the castle building, leaving the outer defences open for the earl's men to seize.

With Grange and his men still within the castle, a ceasefire was agreed while his surrender was negotiated. Grange tried to delay the discussions, no doubt hoping French assistance might arrive, but his own garrison threatened mutiny if he did not surrender. On 28 May his troops were allowed to go free, but it was discovered that Grange and his

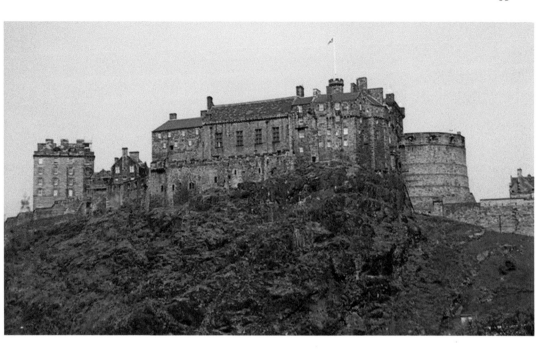

Above: From its dominant position on Castle Rock, Edinburgh Castle can be viewed from miles around the city. (Photo © Sarah Charlesworth cc-by-sa/2.0)

Right: The view up the Royal Mile towards the castle. This area was extensively damaged during the bombardments from the castle.

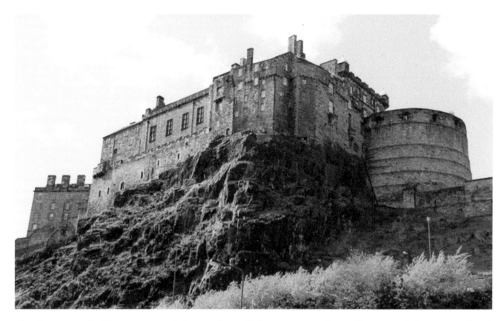

The distinctive half-moon area of the castle is all the remains of David's Tower. (Photo © Richard Croft cc-by-sa/2.0)

The original site of the Mercat Cross where Grange and his men were executed. (Photo © kim traynor cc-by-sa/2.0)

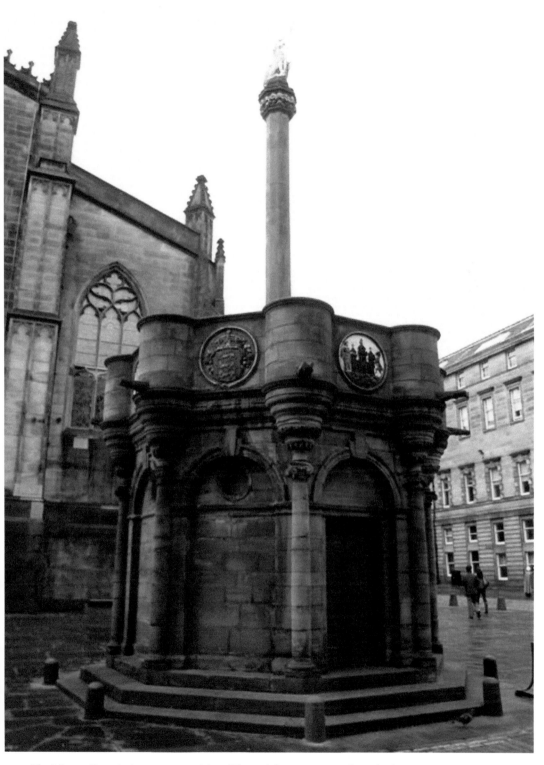

The Mercat Cross in its current position. (Photo © kim traynor cc-by-sa/2.0)

brother had been working with two jewellers inside the castle minting coins, and all four were executed at the Mercat Cross.

The castle was almost entirely rebuilt in 1578, with the damage caused to the castle during the siege shaping the castle as we see it today. A portcullis gate was built to replace Constable's Tower, and the distinctive half-moon battery that can be seen on the southern face of the castle is all that remains of David's Tower.

In 1640, a siege at the castle was the exact opposite of the Lang Siege, leading to some referring to it as the Fast Siege. At the start of the Second Bishops' War, Alexander Leslie was appointed as Commander in Chief of the Covenanter forces against the army of King Charles. The castle was under the control of Archibald Haldane, on behalf of the king. Leslie, along with several other nobles and an army of around 1,000 men, approached the castle with a request to speak to Haldane. It was their hope that through negotiating, they could persuade him to hand over the castle to the Covenanter forces. He refused, and Leslie turned his men around and marched away from the castle.

As he left however, a petard (an early explosive device comprising of a small wooden or metal box filled with gunpowder) was placed on the outer gate of the castle. As soon as it exploded, Leslie turned his men back to the castle again and they all rushed in

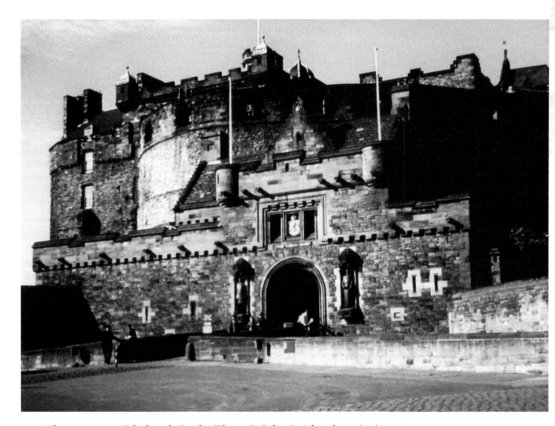

The entrance to Edinburgh Castle. (Photo © Colin Smith cc-by-sa/2.0)

Balgonie Castle, home of Alexander Leslie.

through the gate and scaled the walls, catching the garrison inside completely by surprise. The castle was taken in just thirty minutes, with no lives lost, leading to it being described as 'the most effective capture of Edinburgh Castle ever carried out'.

The final siege of the castle took place in 1745. The Jacobite forces had tried to take the castle in the 1715 uprising, but the ladders they had brought were too small to scale the castle walls. During the 1745, they were back, under the command of Prince Charles Edward Stuart, better known as Bonnie Prince Charlie. In September 1745, the Jacobite army arrived in Edinburgh and took the town relatively unopposed. But as with earlier invasions, they wanted control of the castle. The castle was under the command of George Preston, and it was felt that with there being enough supplies within the castle to survive for months, and the Jacobites having no heavy artillery, there was no threat to the castle. Some shots were fired from the battlements – three as they approached on 16 September, and a further single shot at their camp on 18 September – but little more was done. This enraged the townsfolk, who felt that the country's capital city should have been defended.

Bonnie Prince Charlie took up residence at Holyrood Palace, while his troops set up camp nearby, and initially they did not even prevent fresh supplies of perishables being taken into the castle by the townsfolk, including milk and butter. The discovery of a letter being smuggled into the castle in the butter, however, brought an end to that. The Jacobite forces positioned themselves in various locations around the castle and waited.

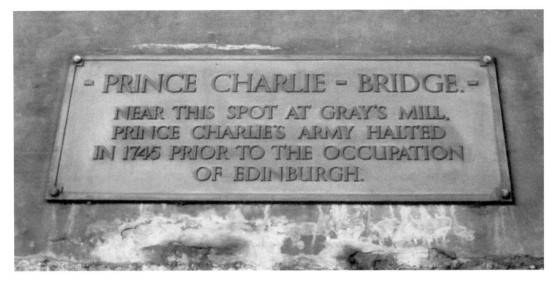

A plaque marking the location the Jacobite forces rested prior to marching to Holyrood. (Photo © kim traynor cc-by-sa/2.0)

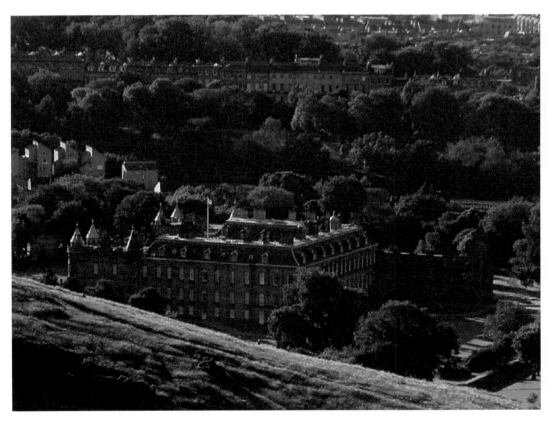

Holyrood Palace, where Bonnie Prince Charlie took up residence while his army camped on the grounds. (Photo © Rudi Winter cc-by-sa/2.0)

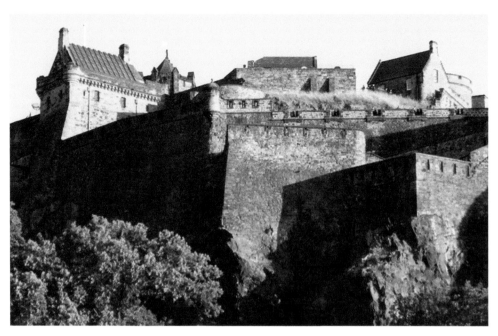

The Argyle Battery was added to Edinburgh Castle as part of the reinforcements after the 1715 Jacobite uprising and housed many cannons. (Photo © Colin Smith cc-by-sa/2.0)

Once a pub, this building was where Bonnie Prince Charlie met with his officers during his occupation of Edinburgh. (Photo © kim traynor cc-by-sa/2.0)

Cannonball House on the Royal Mile has an unlikely claim that a cannonball fired from the castle during the Jacobite siege was lodged in its wall. (Photo © kim traynor cc-by-sa/2.0)

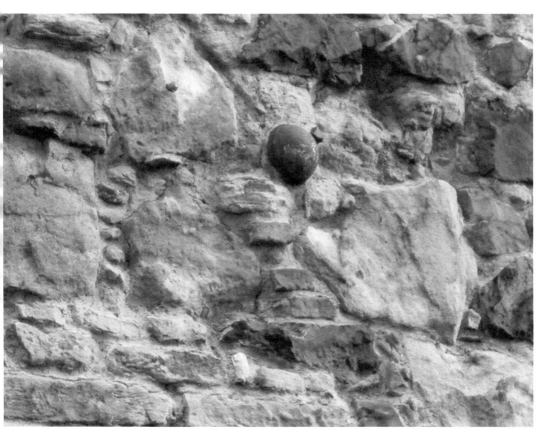

A close-up of the cannonball at Cannonball House. (Photo © kim traynor cc-by-sa/2.0)

On 29 September, a message was sent from within the castle to the Provost of Edinburgh stating that unless open communications with the castle were once again restored, they would open fire with the cannons on the town to try to remove the Jacobites, at risk of great damage to the buildings. Knowing the public unrest at the lack of protection offered by the castle, to see the forces within then open fire on the town was unthinkable to the provost, and so he approached Prince Charlie, who agreed to enter into negotiations, thus removing the immediate threat to the town.

A period of peace followed while instructions were awaited by the castle guard from London, but on 1 October that all came to an end when, for an unknown reason, townsfolk taking food to the castle were fired upon by Jacobite soldiers. The garrison within the castle responded by opening fire from their cannons, destroying and damaging several buildings in which the Jacobites had been hiding out. As a result, Prince Charlie reinstated the blockade on the castle, and once again banned any communication with those inside. This left the castle no option but to retaliate further, and for several days after they fired on the buildings connected with the Jacobite forces, and at night battalions would leave the castle and set fire to other buildings. Witnessing the destruction of the town and the death of both his own troops and townsfolk, Prince Charlie once again agreed to allow

communication with the castle in return for a ceasefire. A period of uneasy calm returned to the town until 1 November, when the Jacobite forces seemingly gave up any hope of taking the castle and left Edinburgh.

The castle would never again see military action, and from the late eighteenth century, it was used to hold prisoners from the ongoing wars. In 1814, the castle was declared a National Monument, and after a number of prisoners escaped, it was no longer used as a prison. Throughout the nineteenth century into the twentieth century extensive restoration work was carried out, and in 1927 the Scottish National War Memorial was established within the castle.

6. Buildings and Memorials

Edinburgh has had a long and extensive military connection, as demonstrated throughout this book. There are many military buildings and memorials that remain within the city, with the following not being a comprehensive list.

The Nelson Monument

Sited high above the city on Calton Hill is the Nelson Monument, commemorating Admiral Lord Nelson. When word reached Edinburgh of Nelson's victory at the Battle of Trafalgar in 1805, and subsequent death from his injuries, it was decided that a memorial for him should be constructed in the city. The initial design was turned down, but a later design based on an upturned telescope was agreed and work began in 1807.

A number of options were put forward to raise funds, including granting access to the fee-paying public, or allowing injured sailors to live there. Eventually it was occupied by a Mrs Kerr, the widow of a petty officer, who rented the premises to run as a small restaurant. The prominent position and height of the monument also allowed it to be used as a signal to those in Edinburgh of the arrival of shipments arriving by sea at Leith, and this led to another use in 1852, when a time ball was installed at the top of the tower.

The idea of the time ball was that at exactly 1 p.m. the ball would drop. As the tower could be seen from the ships anchored in the Forth, this would allow the captains to accurately know the time for calculating their onward journeys. While it was a good idea in principal, it was flawed. The frequently misty sky around the Forth prevented the captains from seeing the tower. A solution was found by means of an audible signal, and the one o'clock gun was introduced at Edinburgh Castle in 1861.

The Covenanters' Monument

In the Grassmarket area of the city, a large memorial stone can be found to commemorate the Covenanters, a Presbyterian group who stood against the changes the monarchy tried to impose on Scotland during the seventeenth century.

The opposition led to warfare between the two opposing religious factions, as the authorities sought to crush the Covenanter movement. One particularly brutal incident took place after the Battle of Bothwell Brig, in June, 1679. Over 1,000 Covenanter troops were captured and imprisoned in a walled area at Greyfriars Kirkyard. With no shelter or sanitation, and each man being given only 4 oz of bread a day, conditions were unimaginable. Many died within what became known as the Covenanters' Prison, while other were taken and executed. Only a few managed to escape. In November, the 257 men who remained alive were sentenced to deportation

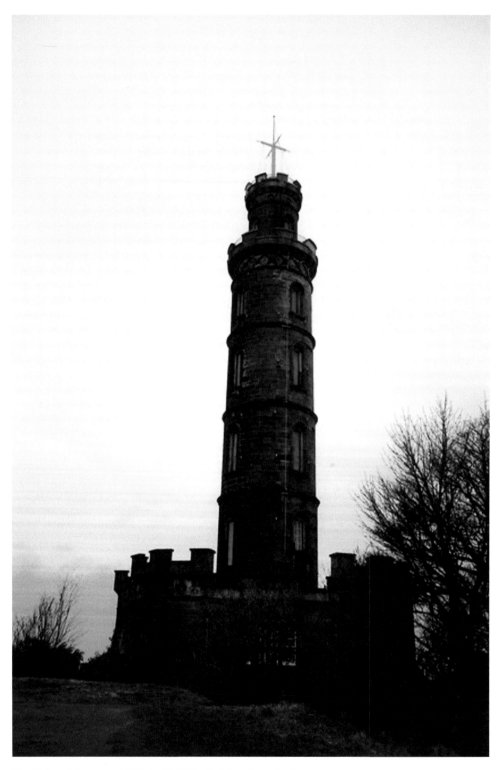

The Nelson Monument. (Photo © N Chadwick cc-by-sa/2.0)

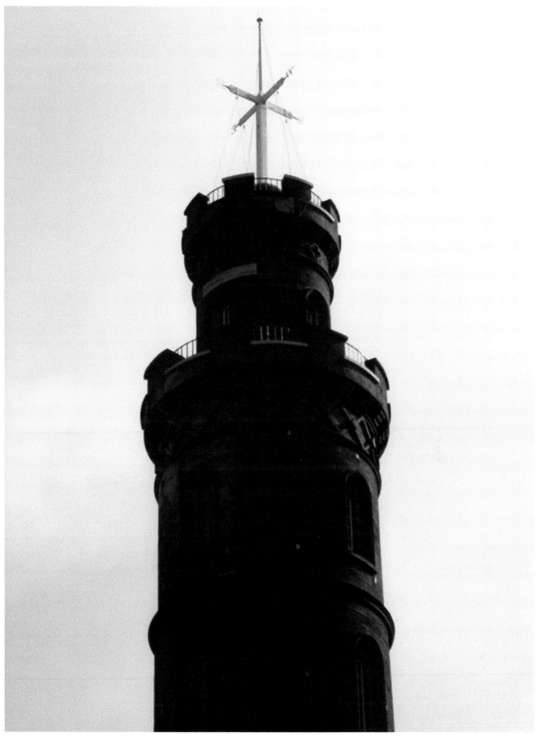

The spire on top of the Nelson Monument on which the Tome Ball rises and Falls.
(Photo © N Chadwick cc-by-sa/2.0)

Left: The Covenanter's Prison in Greyfriars Kirkyard.

Below: The Covenanter's monument in the Grassmarket with the shadow of the gallows beside.

to the American colonies, but the ship was sunk in a storm at Orkney, with only forty-eight men surviving.

The memorial, placed there in 1937, marks the approximate location of the gallows where over 100 Covenanters were hung.

The Second Boer War

In 1899, the Second Boer War, also known as the South African War, started between the Boer states – the South African Republic and the Orange Free State – and the British Empire. The Boer states opposed the British influence in South Africa and their initial attacks proved successful, with them wining several battles.

The arrival of reinforcements for the British Empire massively outnumbered the Boer forces, and after successfully seizing the main towns, control of the two states was taken

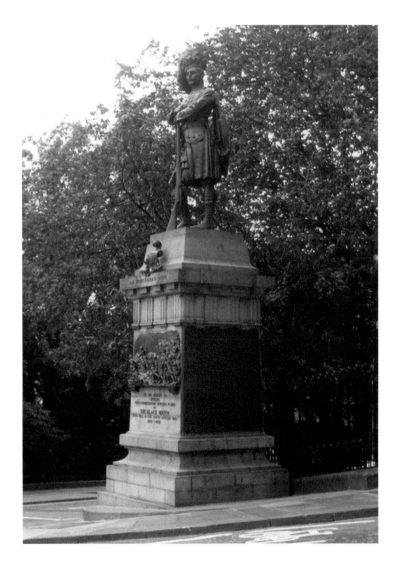

The Black Watch Memorial. (Photo © Nicholas Mutton cc-by-sa/2.0)

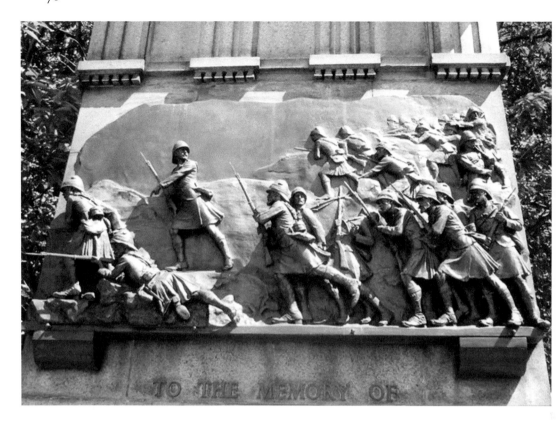

TO THE MEMORY OF

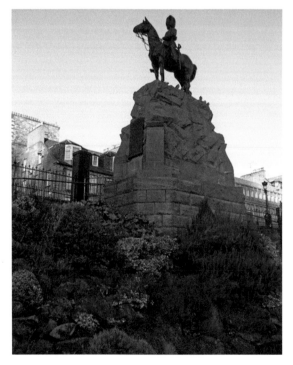

Above: Close-up of the plaque on the Black Watch Memorial.
(Photo © kim traynor cc-by-sa/2.0)

Left: Memorial to the Royal Scots Greys.
(Photo © michael ely cc-by-sa/2.0)

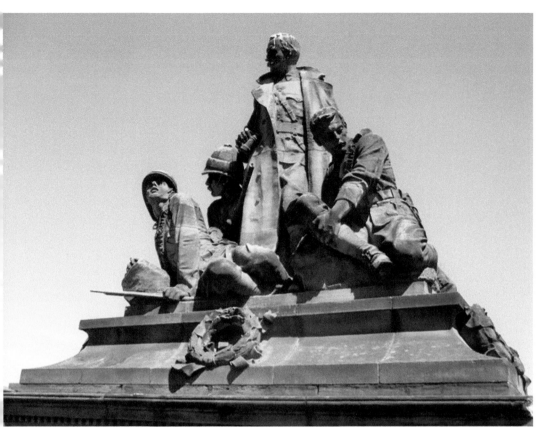

Memorial to the King's Own Scottish Borderers. (Photo © kim traynor cc-by-sa/2.0)

by the empire. The Boers were not for submitting however, and a two-year guerrilla war followed, until a peace treaty was finally settled in May 1902.

There are a number of memorials in Edinburgh. In Market Street, at the corner of North Bank Street, a statue of a Black Watch soldier in full traditional Highland dress can be found, to commemorate the men of the Black Watch who fell in the war. On Princes Street stands the memorial to the Royal Scots Greys, which also commemorates those lost in First and Second World Wars, and on the North Bridge a memorial to the soldiers of the King's Own Scottish Borderers who gave their lives can be found.

National Monument

On Calton Hill a curious Ancient Greek-like structure can be seen. Although appearing ruinous at first glance, this is in fact the never finished National Monument to the fallen of the Napoleonic Wars.

At the end of the wars, it was felt that the monument should be erected to commemorate those who gave their lives protecting the country, and it was decided the Calton Hill, where it would be visible all around, was appropriate. A design was agreed, based on the Athenian Acropolis in Athens, paying homage to the nickname the 'Athens of the north',

which is often used for Edinburgh. Work started in 1822, with the massive foundation stone being laid by King George IV at a ceremony celebrating the start of the work. The plans were to create what appeared to be a Greek temple on the outside; internally the building would house a functioning church with catacombs below.

Many prominent figures of Edinburgh contributed towards the cost of the monument, yet the ambitious project required equally ambitions funding to be raised. Despite a distinct lack of money, by 1826, with the foundations already in place, it was decided that work could not wait any longer. The twelve massive Doric columns were constructed, a task that proved to be extremely difficult, with each section requiring to be manhandled from the quarry to the top of the hill, a distance of around 3 miles, requiring seventy men and twelve horses to haul each piece. By 1829, the funds were exhausted, and with no more money available, work on the project ceased.

The extensive expansion Edinburgh was undergoing at the time was blamed, with it being said that funding was being forced to be stretched across many projects. The high costs for the construction of the National Monument made it difficult to justify allocating too much of these funds to a single project. Several attempts were later made to raise the money required, but the memorial remains very much incomplete today, resulting in it being known locally as 'Edinburgh's Disgrace'.

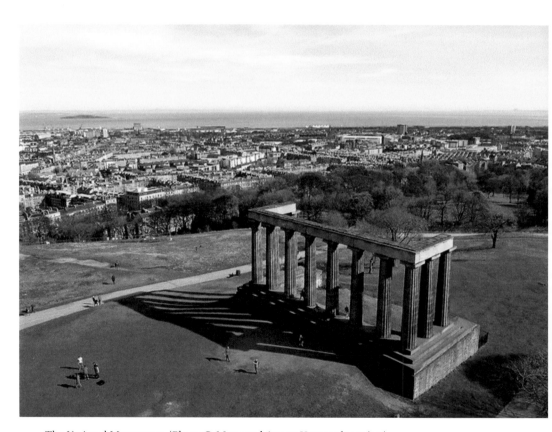

The National Monument. (Photo © Mary and Angus Hogg cc-by-sa/2.0)

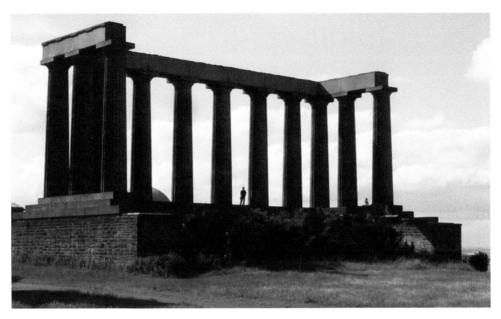

The rear of the National Monument. The visitor gives an idea of the sheer scale of the structure. (Photo © kim traynor cc-by-sa/2.0)

Leith Fort

In 1779, the port of Leith found itself once again under threat, but this time from a new foe, when three American warships entered the Forth. To the reader, this may seem quite extraordinary; however, this was the time of the American Wars of Independence. The founder of the American navy and captain of the small fleet of ships was Scotsman John Paul Jones, and Edinburgh Castle was being used as a prison for captives who had fought on the American side. Under the threat of an imminent attack, the people of Leith were grateful when a storm struck, and high winds forced the American ships out to the North Sea.

It was a lucky escape, that once again reminded the authorities of the importance of Leith, and they were alarmed at the lack of any defences. Nine heavy guns were hastily brought to protect the harbour, but more permanent defences were needed. After considering several options, plans were made for the construction of a fort in Leith. In September 1793, the 1st Royal Artillery Company moved from the castle to the newly completed fort, yet it was a defence that was proved to not be needed, with no further attacks on Leith.

In 1956, the Royal Army Pay Corps were the last military unit to be based at the fort, and when they left the interior of the complex was demolished, and housing was built. Still surrounded by the perimeter wall, gates and guardhouse, the housing estate became known simply as 'the fort', and became notorious as a difficult and challenging place to live. In 2013, the earlier flats were demolished and new affordable housing was built.

The Martello Tower, Leith

In 1809, with the threat from French forces during the Napoleonic Wars, a Martello tower was constructed in Leith to protect the docks and the River Forth. These small,

The notorious flats behind the wall for Leith Fort. (Photo © kim traynor cc-by-sa/2.0)

The former Guardhouse at the Leith Fort. (Photo © kim traynor cc-by-sa/2.0)

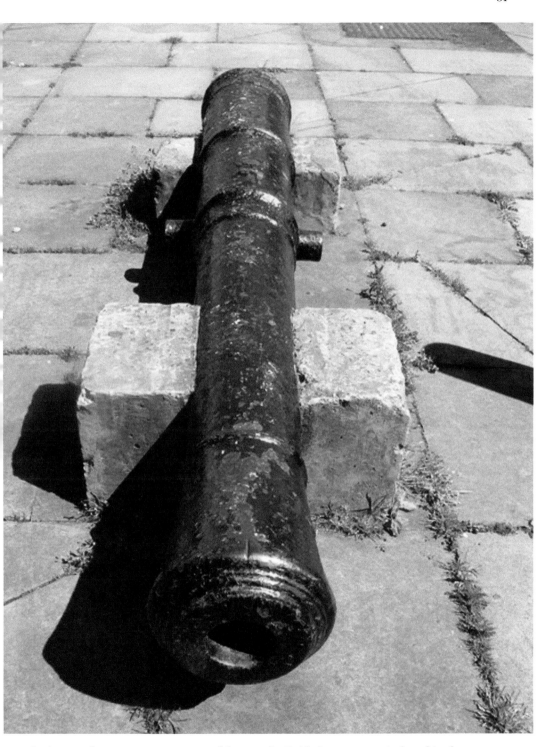

A nineteenth-century cannon, one of four at the Leith Fort as a reminder of its former use. (Photo © kim traynor cc-by-sa/2.0)

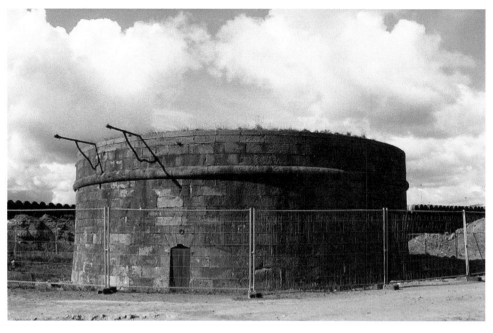

The Martello Tower at Leith – now on reclaimed land, meaning much of it cannot be seen. (Photo © Richard Webb cc-by-sa/2.0)

defensive towers, topped with a gun placement, were constructed across the British Empire to deal with the threat of the French fleet.

Costing £17,000 to build, the tower was circular in shape and stood at around 10 meters high, with 2-metre-thick walls. But as with Leith's fort, it was never used in aggression as Leith was not threatened or attacked again. In 1815, with the end of the war, the tower was no longer needed, and it fell into a state of disrepair until 1850, when the Royal Engineers restored it for the use of the men of the Royal Artillery based at Leith Fort. By 1869, it was again abandoned, and has been left to the elements since.

The Abraham Lincoln Statue
At the Old Calton Hill Cemetery on Waterloo Place a statue of Abraham Lincoln stands largely forgotten. This is the Scottish-American Soldiers Monument, also known as the American Civil Wars Memorial, and is dedicated to the Scottish soldier who fought with Abraham Lincoln's forces in the American Civil War.

The war was prompted by Lincoln's action to end slavery in America, resulting in some of the Southern States announcing their intention to break away from the United States. A four-year war followed, and while the British government remained neutral, individual soldiers felt strongly enough to travel to America to fight for what they saw as a great cause.

The circumstances around the construction of the monument, which was the first statue of Lincoln erected outside of America and the only monument to the American Civil War outside of the United States, are rather unusual. When one of the soldiers' wives, known simply as Mrs McEwan, sought to claim her army widow's pension after

The Scottish-American memorial. (Photo © Kevin Rae cc-by-sa/2.0)

his death she received little help from the British authorities, and so she turned to the US Consul for help. Once they listened to the story of her husband's involvement in the Civil War, they contacted the Edinburgh Council to request a plot of land be allocated for a memorial. This was agreed, with the funding to come from America. With the financial aid of Andrew Carnegie, the Scottish industrialist who had become one of the richest men in America, and John D. Rockefeller, the bronze statue was cast in America and shipped to Scotland.

The statue, which was officially unveiled in 1893 in front of a large crowd of both British and American citizens, commemorates Sergeant Major John McEwen, Lt Col. William L. Duff, Robert Steedman, James Wilkie, Robert Ferguson and Alexander Smith.

Wojtek the Bear

We end this section of the book with an uplifting tale and the statue of a rather friendly looking bear.

The story of Wojtek started in 1943, when a group of soldiers from the Polish 2nd Corps were released from the Soviet forced labour camps by Stalin after the Nazi invasion of the Union of Soviet Socialist Republics (USSR). The men had 'adopted' a bear cub, and when they returned to join the Polish forces again, they took the bear with them to help keep morale high.

The memorial to Wojtek the bear. (Photo © M J Richardson cc-by-sa/2.0)

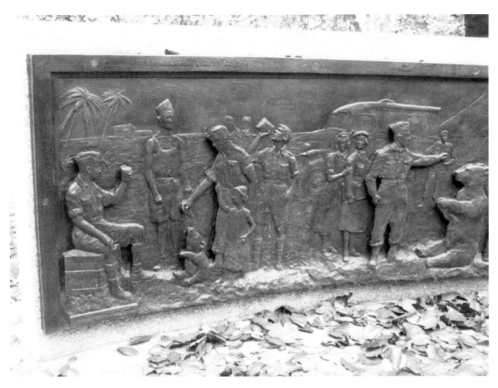

The first part of the relief behind the Wojtek statue. Photo © M J Richardson (cc-by-sa/2.0)

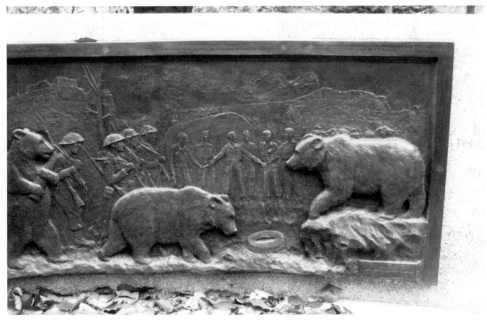

The second part of the relief behind the Wojtek statue. Note Wojtek carrying the artillery shell as a human would. (Photo © M J Richardson cc-by-sa/2.0)

As they travelled from their captivity through Iran and Egypt, towards Italy, the bear both grew and took on several of the mannerisms of the troops, who no doubt took delight in teaching him. By the time he was fully grown, he could help carry supplies, salute and even enjoyed both wrestling and drinking beer with the soldiers. When they returned to active duty, there was a problem however, as it was strictly forbidden for soldiers to take pets with them into battle, leading to what must be one of the most bizarre situations. The men were reluctant to leave the bear behind. He had been instrumental in getting them through their long journey back and was considered a key member of the group. The bear was therefore enlisted as a private in the 22nd Artillery Transport Company of the 2nd Corps, and named Wojtek, meaning 'Joyful Warrior'.

Wojtek gave active service for the remainder of the war, with it being said that during the Battle of Monte Cassino, he assisted in moving crates of ammunition, lifting them with two 'hands' while standing upright, just as a human would do, as that was how he had been taught. The bear continued to help boost morale, and the image of a bear carrying an artillery shell became the official symbol of the 2nd Company.

At the end of the war, 22nd Artillery Transport Company, complete with Private Wojtek, were transferred to south-east Scotland, where most decided to stay, and following the demobilization of the company in 1947, Wojtek was taken to Edinburgh Zoo to be looked after. His fellow soldiers did not forget him, and they visited him regularly up until his death in 1963.

To commemorate the rather unusual tale of the soldier bear, a bronze statue of Wojtek was unveiled in Edinburgh's Princes Street Gardens in 2015. The memorial not only remembers the contribution made by Wojtek, but also the Polish soldiers he served beside, and the close ties that remain between Scotland and Poland after the war.

7. Edinburgh in More Recent Times

After centuries of peace, Edinburgh once again experienced the devastating effects of conflict when it was bombed during the First World War.

It was on the evening of Sunday 2 April 1916 when the first ever air raid took place in Scotland, when two German Zeppelins flew across the Firth of Forth. It is believed that the Zeppelins had intended to meet two further airships but one had got lost and the other had to turn back due to technical difficulties. This is possibly the reason that rather than attack their original targets of the docks at Rosyth and any ships moored in the Forth, the continued to fly over the city.

The first bombs struck Leith just before midnight, hitting a bonded warehouse and lighting up the night sky. The aerial bombardment across Edinburgh continued for over half an hour, with a total of twenty-four bombs dropped, with the intention

The White Hart Inn in the Grassmarket was damaged during the Zeppelin bombing raid, killing one person. (Photo © kim traynor cc-by-sa/2.0)

This stone marks
the site
of a bomb
dropped from
Zeppelin
Airship L14
on the
night of
2nd April 1916

A memorial plaque indicating where one of the bombs landed close to the White Hart Inn. (Photo © kim traynor cc-by-sa/2.0)

being to cause as much death and destruction as possible. It was clear that despite the change of target the pilots knew exactly where they were attacking, with one of the airships flying towards Edinburgh Castle, which would have sent a strong message out to the people of Scotland had it been hit. In one remarkable escape, a bomb went through four storeys of a tenement property, but no one was hurt. Thirteen people did however lose their lives during that single period of bombing, and a further twenty-four were injured.

During the Second World War, Edinburgh managed to escape extensive damage despite there being a total of eighteen bombing raids made on the city. Primary targets were the bridges across the Forth and the ports of Leith and Rosyth, and gun placements mounted all round, including on the Forth Islands, were contributing factors in preventing more attacks. Twenty people did still lose their lives, and a further 210 were injured.

Today, Edinburgh's military heritage is very much on display, celebrated and ongoing. Edinburgh Castle had gone from being the most sieged in the country to the most visited in the country, with more than one and a half million people passing through the gates every year. Within the castle there stands the National War Museum, along with the museums for the Royal Scots and the Royal Scots Dragoon Guards and it remains the headquarters for the Royal Regiment of Scotland.

On the city's Collington Road sits the Redford Barracks. Base for a battalion of the Royal Regiment of Scotland, the barracks were built between 1909 and 1915 to provide both military and cavalry barracks and were the largest military installation built in Scotland since Fort George, near Inverness, in 1748, with the infantry barracks being designed to house 1,000 men. During the First World War, the barracks were used for a short time as a military prison for German soldiers. The Dreghorn Barracks are newer, being built between 1937 and 1939, but were built in the grounds of Dreghorn Castle, a seventeenth-century mansion that was used by the War Office between 1893 until it was demolished in 1955. They are currently the home of the 3rd Battalion the Rifles, one of just four 'strike' infantry battalions within the British army. Since becoming established there in 2007, the '3 Rifles' have deployed on five tours to Iraq and Afghanistan, along with many other operational and training missions across the world. In 2021, there are plans for the 650 riflemen to move to Catterick in North Yorkshire, and it is not clear what the proposals for Dreghorn are yet.

Probably the most visible military display, for those fortunate enough to visit the city in early to mid-August, is the Edinburgh Military Tattoo. This celebration of the military from across the globe was inspired by a relatively simple show named 'Something About a Soldier' that was performed at the Ross Bandstand, in the shadow of the castle, in 1949. The following year, the first Military Tattoo was held, with the name coming from the term 'doe den tap toe', meaning 'turn off the taps', which relates a Dutch tradition for the military band to play to signal the last call for the soldiers to return to their base from the local pubs! It was later shortened to 'tap toe', and developed into Tattoo.

The performance of military bands from across the world has taken place every year since on the Esplanade in front of the gates to Edinburgh Castle, and has grown

The Spitfire at Edinburgh Airport. (Photo © M J Richardson cc-by-sa/2.0)

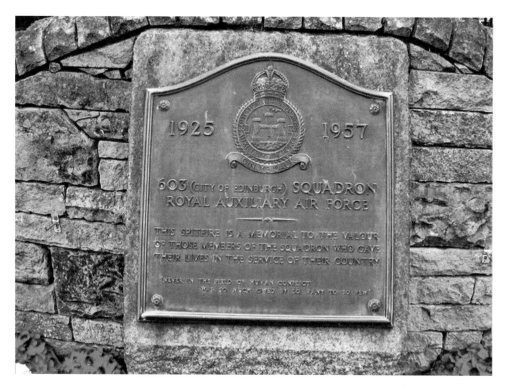

Memorial plaque at the Spitfire. (Photo © M J Richardson cc-by-sa/2.0)

The entrance to the Dreghorn Barracks. (Photo © michael ely cc-by-sa/2.0)

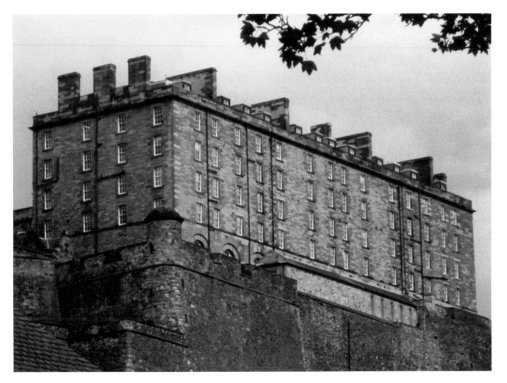

The New Barracks at Edinburgh Castle. (Photo © kim traynor cc-by-sa/2.0)

The Redford Barracks. (Photo © Anne Burgess cc-by-sa/2.0)

Hogmanay preparations at the Ross Bandstand. (Photo © kim traynor cc-by-sa/2.0)

The Castle Esplanade around 1936, now the site of the Edinburgh Military Tattoo. (Photo © George W Baker cc-by-sa/2.0)

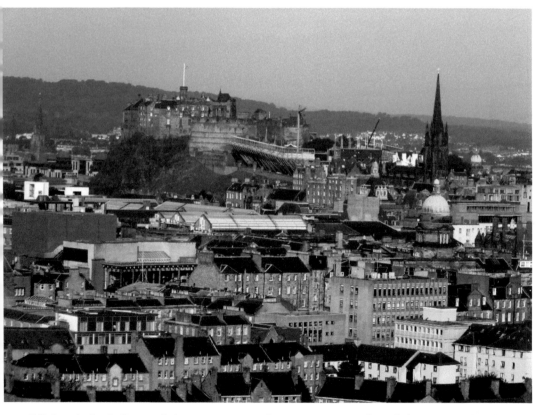

Edinburgh Castle from Salisbury Crags. Note the temporary grandstands being put up in the Esplanade for the Tattoo. (Photo © David Smith cc-by-sa/2.0)

Close-up of the temporary grandstands during construction. (Photo © David Smith cc-by-sa/2.0)

considerably. The first show attracted 6,000 people, a significant achievement at the time, but it is dwarfed by the current audience of over 200,000, with a further hundred million watching the display on television. Such is the popularity of the show that the tickets are always sold out months in advance.

Throughout this book it has only been possible to explore the main parts of Edinburgh's rich historical heritage, and a visitor will not need to look far to find the many symbols that remain across the city.

Bibliography

Anon, *Letters and Passages between his Excellency the Lord General Cromwell and the Governour of Edinburgh Castle* (Edinburgh, 1650)

Arnot, Hugh, *The History of Edinburgh from the Earliest Accounts to the year 1780* (Thomas Turnbull: Edinburgh, 1816)

Caldwell, D. 2019 May 2. *Edinburgh Castle Under Siege 1639–1745. Journal of the Sydney Society for Scottish History.* [Online]

Grant, James, *Memorials of the Castle of Edinburgh*, William Blackwood and Sons (Edinburgh, 1850)

Paul, J. Balfour. 'Edinburgh in 1544 and Hertford's Invasion.' *The Scottish Historical Review*, vol. 8, no. 30, 1911, pp. 113–131. *JSTOR*, www.jstor.org/stable/25518290.

Rankin, Edward B. 'Whitekirk and "The Burnt Candlemas".' *The Scottish Historical Review*, vol. 13, no. 50, 1916, pp. 133–137. *JSTOR*, www.jstor.org/stable/25518888.

Reid, W. Stanford. 'The Coming of the Reformation to Edinburgh.' *Church History*, vol. 42, no. 1, 1973, pp. 27–44. *JSTOR*, www.jstor.org/stable/3165044.

Wilson, Daniel, *Memorials of Edinburgh in the Olden Times* (Simpkin Marshall and Co., 1858)

About the Author

Gregor was born and raised in the town of St Andrews in Fife. Having been surrounded with history from a young age, his desire to learn about the past was spiked through his grandfather, a master of gold leaf work whose expertise saw him working on some of the most prestigious buildings in the country, including Falkland Palace. After talking to other staff in these monuments, he would come back and recall the stories to Gregor, normally with a ghost tale thrown in for good measure.

Growing up, Gregor would read as many books as he could get his hands on about ghost lore, and going into adulthood, his interest continued and he would visit many of the historic locations he had read about. After taking up paranormal investigation as a hobby, Gregor started to become frustrated at the lack of information available behind the reputed haunting. He has always felt it is easy to tell a ghost story, but that it is not so easy to go back into the history to uncover exactly what happened, when and who were the people involved that might lead to an alleged haunting. He made it a personal goal to research tales by searching the historical records to try to find the earliest possible accounts of both what had happened and the first telling of the ghost story, before it was adjusted as it was handed down from generation to generation. This proved to be an interesting area to research, and Gregor found himself with a lot of material and new theories about what causes a site to be allegedly haunted. After having several successful books published about the paranormal, Gregor found himself uncovering numerous forgotten or hidden tales from history. These were not ghost related, but were stories too good to remain lost in the archives, and he looked to bring the stories for specific towns together to tell the lesser-known history, often including the darker side.

Gregor's first book in this area was *Secret St Andrews*, telling the long and often brutal history from his own neighbourhood. He has since gone on to write several other books in the 'Secret' range, and with the research for these books uncovering some of the military heritage of the towns and cities, he was delighted to have the opportunity to write *Edinburgh's Military Heritage*, which will be followed by *Stirling's Military Heritage*.